Seasons of Solace

Seasons of Solace

A Story of Healing through Photos and Poems

Janelle Shantz Hertzler

Synergy Books

Seasons of Solace: A Story of Healing through Photos and Poems
Published by Synergy Books
P.O. Box 80107
Austin, Texas 78758

For more information about our books, please write us, e-mail us at info@synergybooks.net, or visit our web site at www.synergybooks.net.

Publisher's Cataloging-in-Publication
(Provided by Quality Books, Inc.)

Hertzler, Janelle Shantz.
 Seasons of solace : a story of healing through photos
and poems / Janelle Shantz Hertzler.
 p. cm.
 LCCN 2009932768
 ISBN-13: 978-0-9840760-4-8
 ISBN-10: 0-9840760-4-2

 1. Bereavement--Poetry. 2. Loss (Psychology)--
Poetry. I. Title.

PS3608.E783S43 2010 811'.6
 QBI09-600125

10 9 8 7 6 5 4 3 2 1

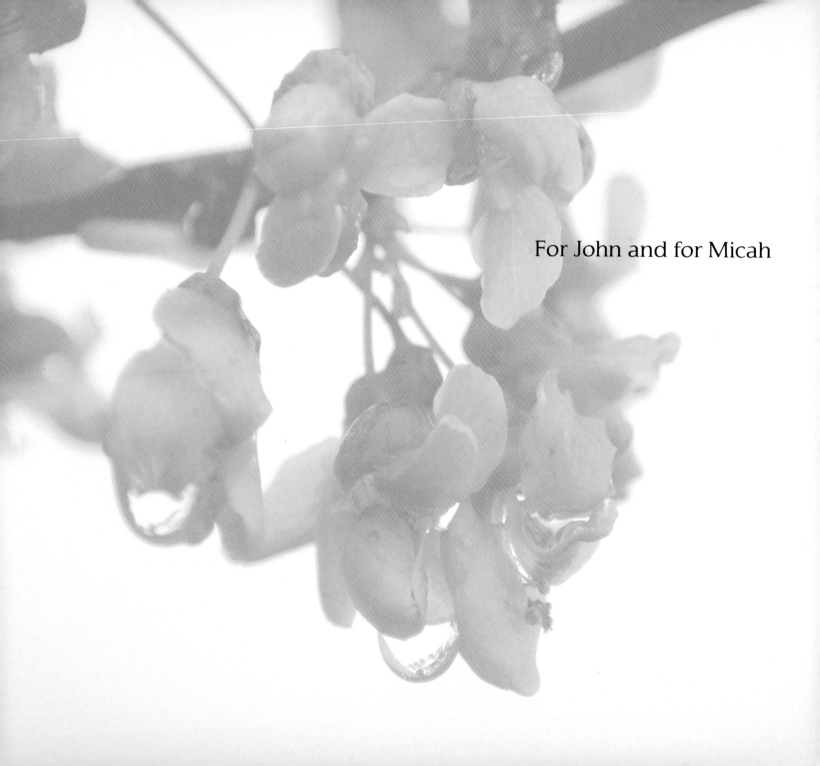

For John and for Micah

Without my family, friends, church family, professors, classmates, and mentors, this book would not have come into existence. Thank you all for the part you played in providing a strong and healing community.

Contents

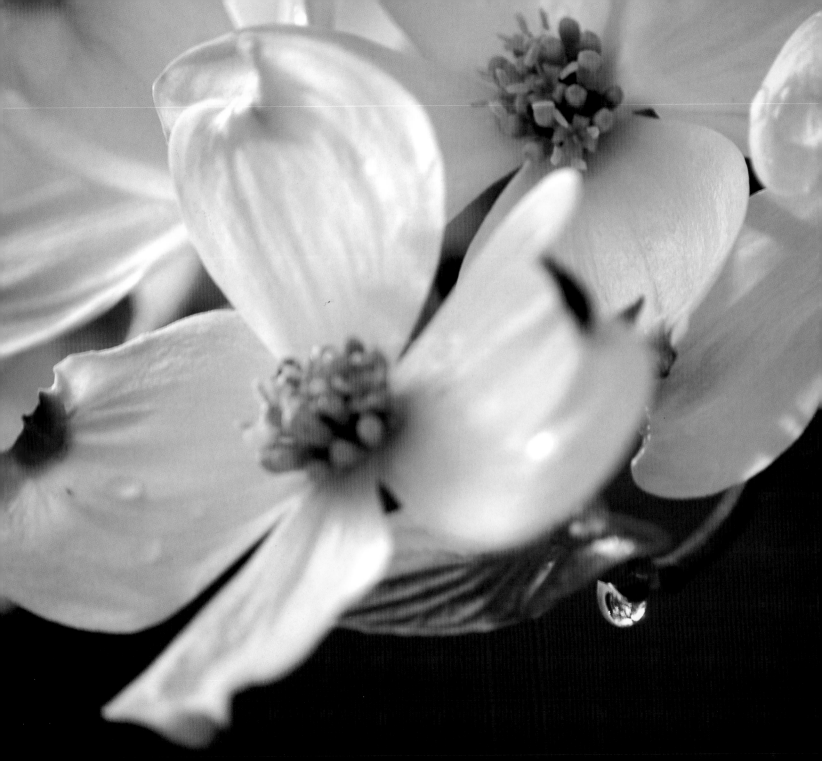

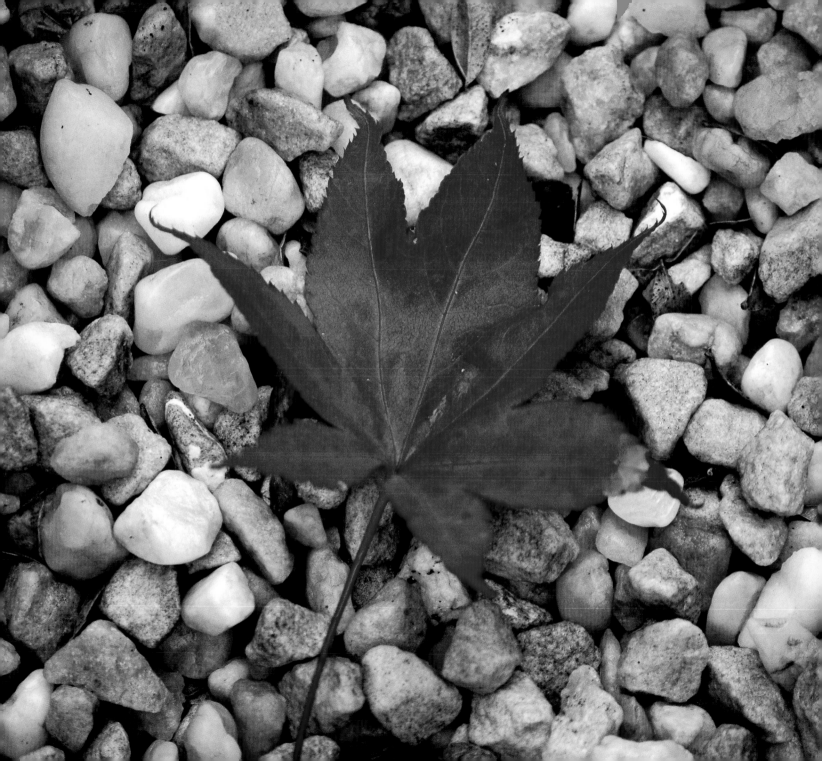

Preface

Sitting in a lawn chair on a river's edge, I looked down and noticed a small, red leaf—alone, resting on jagged pebbles. I couldn't take my eyes from it. Radiant, it lay dying. It was that beauty and death intermingled that captured my attention.

I had spent the past year living with the reality of the death of my husband, John. We were living in Thailand at the time, working with a Mennonite organization. John worked with an economic development program, an AIDS patient program, and in leadership development, and I worked in leadership development and taught English. We had been married four and a half years and had an eighteen-month-old son. On Sunday morning, July 24, John was riding a motorcycle out to a church meeting in the village when he was hit head-on by a drunk driver—killed instantly. Uprooted, my son and I returned to North America.

Having passed the first year in shock and anger, I now found myself inexplicably drawn to this lone, red leaf. I had my compact digital camera with me to get photos of the children playing in the river. I was not a photographer. I only used a camera to document the usual events of life—the cuteness of kids and interesting sights. But unwilling to leave the message of the leaf behind, I picked up my camera and snapped a photo.

Thus began my quest to uncover images in the natural world that speak to the human experience. Within these images, I find meaning that connects with my own personal journey of grief and healing. I am continually amazed at how beauty and death so frequently dwell side by side.

Still, I want to remember that nature is more than just the metaphor that I may find in it. I cannot just read my experiences into it and walk away, thinking that I have gained all it has to offer. Thus the photographs are presented without explanation. The poems alongside the photos may hint at a meaning, but my intent is not to limit the beauty and complexity of nature to what I need it to be for me.

However, all art must to some degree place limits and interpretations on the subject. My choice of frame and focus speaks to the metaphor that I myself bring to the image. Another photographer of the same scene might try different angles and different focal points, writing her own story into the image. Hence these are not images of nature *as it is*—no photo could be. But the images are shaped by the pain, fears, hopes, and joys that I carry with me as I walk in the world.

During this season of grief, I was also doing graduate work, taking several classes in the area of trauma healing. Our instructor invited us to explore our experiences and emotions by using different writing exercises to give expression to our stories. I never thought of myself as a poet, just as I never considered myself a photographer. I couldn't remember the last time I had written a poem before John died. Yet, I needed to find a way to express my journey.

Three summers after John died, I had scheduled a free week to work on an academic paper. However, when I sat down to write, all that wanted to come out was poetry. My sister-in-law wisely advised me to "go with the energy." That week, I must have written twenty poems describing various events and emotions from my grief journey. Looking back, I see that that week was a turning point for me in the healing process. Getting the events and emotions outside of myself and named on paper freed me to explore more of what my life had to offer.

I have discovered that poetry is good medicine, even for those who never imagined they would write it. For me, it was a matter of listening to myself—to the thoughts and emotions that stirred around in my mind and soul—and letting them have an avenue to come out into the light.

Although written in the present tense, most of the poems were created two years after the events took place. It is as if I carried those memories and emotions frozen in my body until I was able to examine them by writing these poems. The writing helped me give language to events that seemed beyond description. I experimented with words until I found the ones that helped me understand and tell my story.

Eventually, I began to notice similar themes in my poetry and photography. I started to put them together and found that they complemented each other, each contributing to a fuller expression of my journey.

Though these poems and photos are an expression of a journey through grief, my hope is that they will be meaningful to people in all seasons of life. Loss is something we all face, and I hope that you will be encouraged to find your own way to give expression to your journey as you read mine.

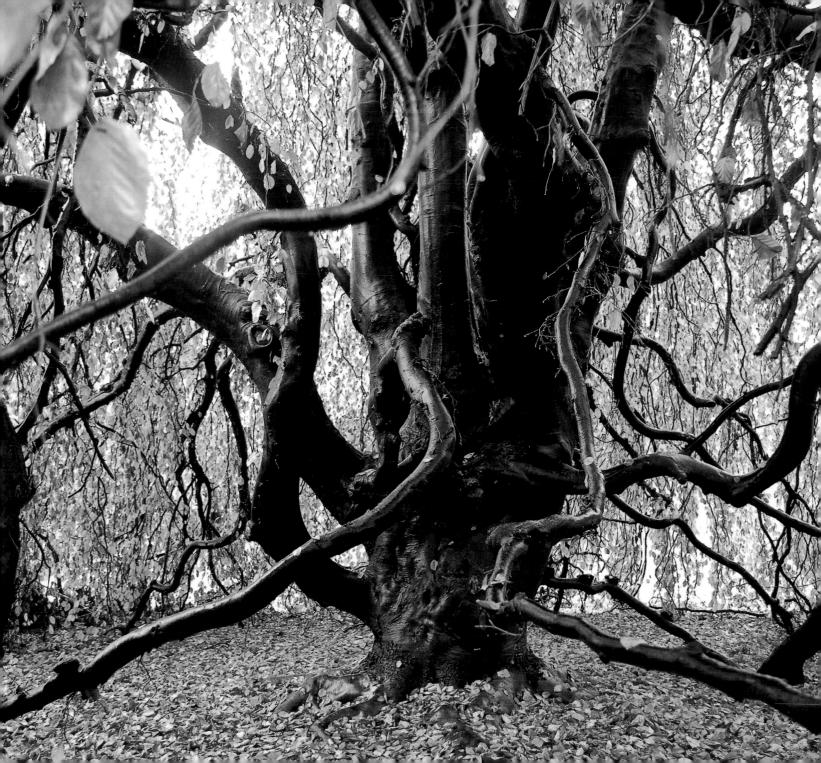

Tangled Testimonies

In a pavilion surrounded by rice fields,
I strain to understand the Lao of
an old woman with a blood-red wad
of betel nut stuffed in one cheek,
*"We've struggled for months
to make ends meet,"*

she begins.
My thoughts drift to John.
Where? A flat? The ditch?
"My son couldn't find work."

Stories that bolster
anxious, waiting wives
rise in my mind.
"He didn't want to leave his family."

A cell phone jingle
interrupts the story of God's goodness,
rare reception in the village.
Wian answers.
"But his wife and children depend on him."

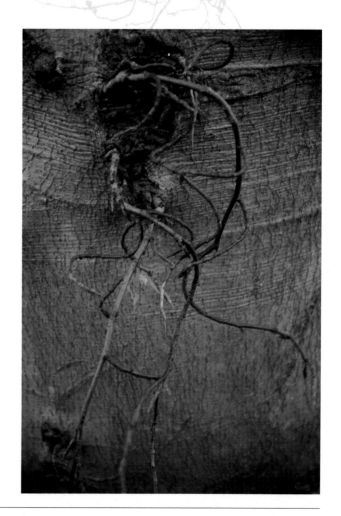

Wian covers her mouth,
trembling, hands me the phone.
 "He went to Bangkok without connections."

I hear a frantic Thai woman.
"Nurse, hospital, accident."
I push the phone to Pastor Joi.
 "God heard our prayer; he found work."

Pastor Joi wide-eyed,
 "He is sending money back; we'll be okay."

puts down the phone,
announces
John is dead.

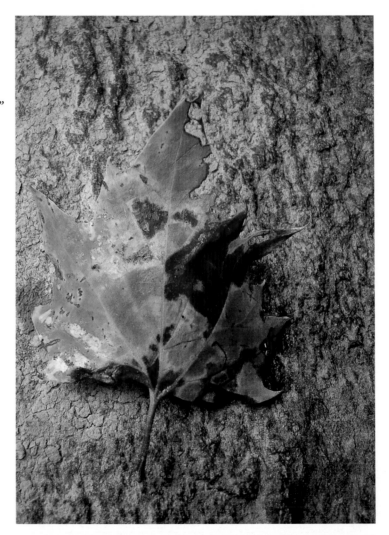

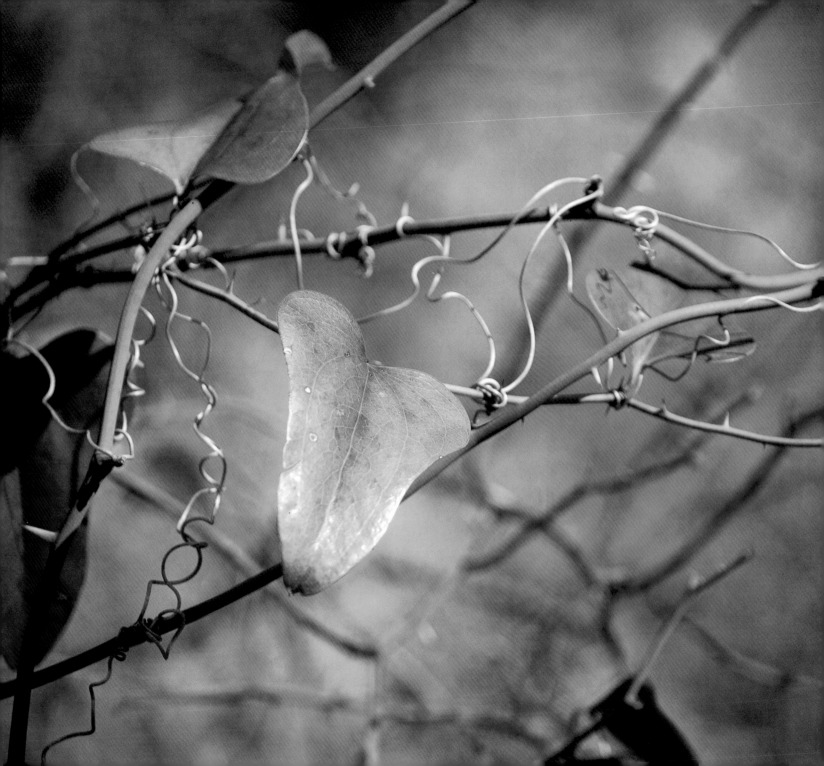

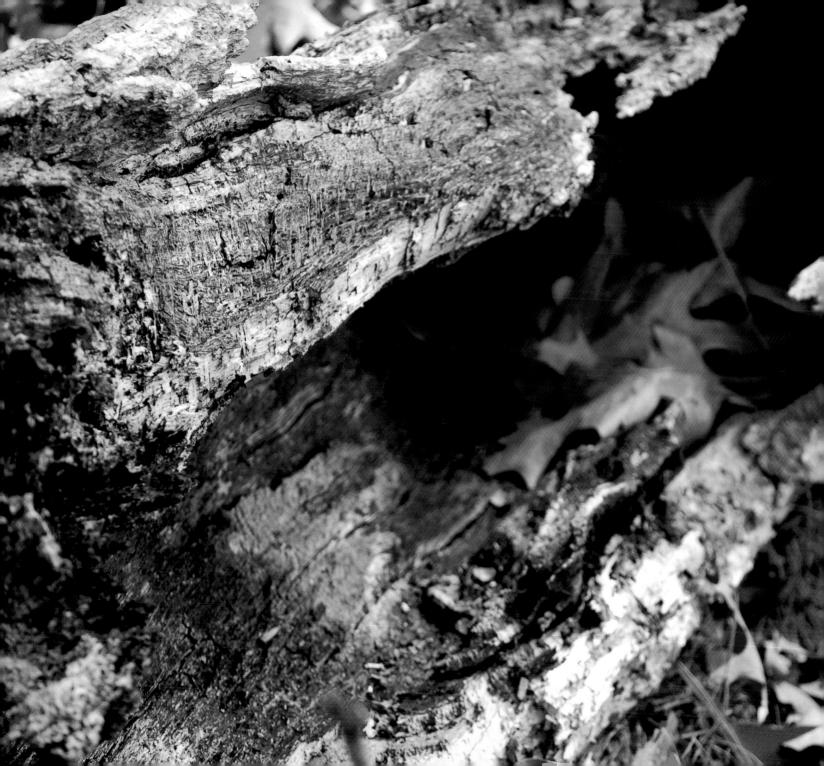

Gap in Time

Black, hollow in a uniform procession of teeth.
Space between the wings of the ark's cherubim.
Nothing in the midst of something.
A black hole surrounded by bright stars,
swallowing anything that comes close.

I sit in an unseen gap in time.
He's dead. I don't know it.
Intuition begins to play tricks.
Dread rises, wadding cotton balls in my throat.

I wrestle it down with more-likely tales,
tales that were truth before. But then
a new reality strikes like an avalanche,
crushing the certainty
to which I yearn to cling.

Glittering stars gulped into the void.
Teeth knocked out in a bitter blow.
Emptiness between the wings of the cherubim,
where God said, "I will be met."

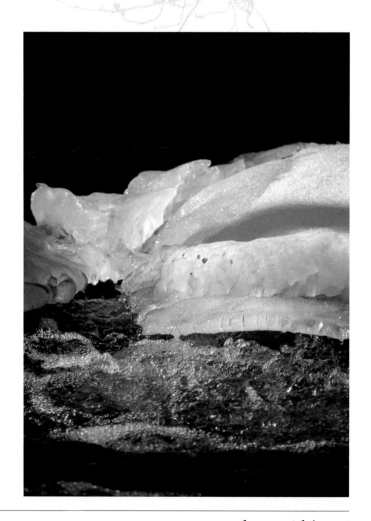

Alone in the gap,
friends and family sleep
on the other side of the world.
No one wants this truth.
The God of the stars and the cherubim
is less complicated.

Happy the life lived in unawareness.
But the truth will not stay hidden long;
those close are seized,
sucked into the nothingness.

Who can bear to swim within
the God of the gaps?

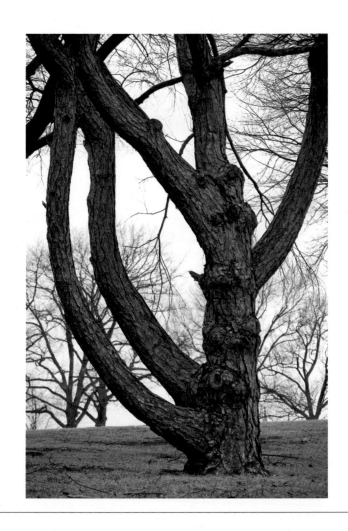

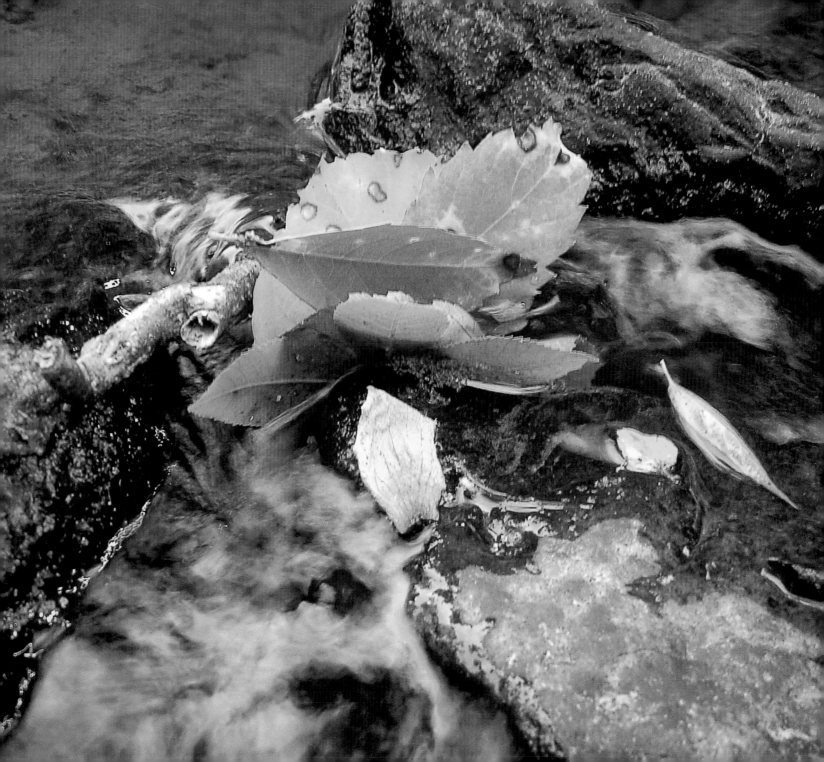

Sing Now

Oh my son,
You have no idea what you lost today,
innocently toddling,
investigating the bushes outside the hospital.

I dressed you in orange this morning;
I see your liveliness in it.
Had I known, would I have chosen
differently?
No, orange sings with you.

Later, playing clapping games with
the women who have gathered,
we smile and laugh with you.
Your light sparks life into our darkness.

Daddy traveled.
You were used to his coming and going.
You're too young to notice this absence,
so play your games and sing your songs.

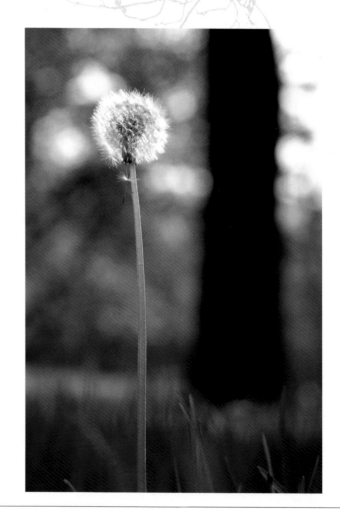

Friday your world will turn upside down;
we will fly away from all that you know:
Daddy, friends, babysitter, neighbors,
cement floors, house lizards,
wearing only diapers
at home.

So give us your grin and Thai bow;
you'll soon forget how it's done.
You will learn of your loss soon enough.
So play your games and sing your songs;
we need your laughter now.

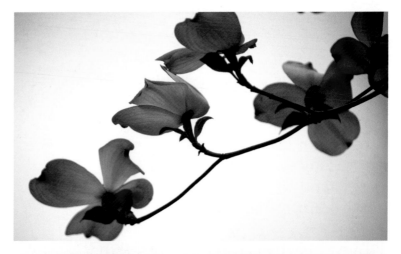

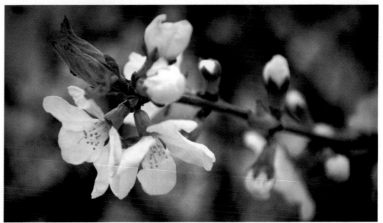

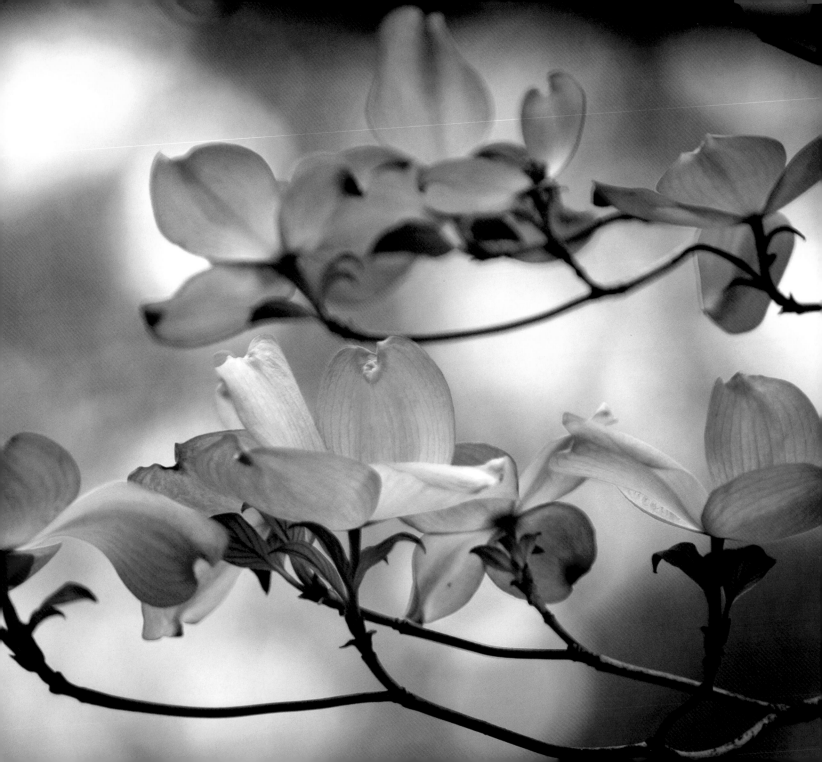

Personal Effects

I watch the police chief lay out:
A backpack with clothes,
toiletries, and books for his
overnight stay,

a broken helmet,
a belt,
a bent wedding band,
a watch,
a passport,
a stone carried as prayer.

Counting cash,
he remarks,
"The locals would have taken this if
they got to the scene before we did.
You're lucky."

Lucky?

These remainders are jammed in my
bottom dresser drawer, and time
dares to move on without him.

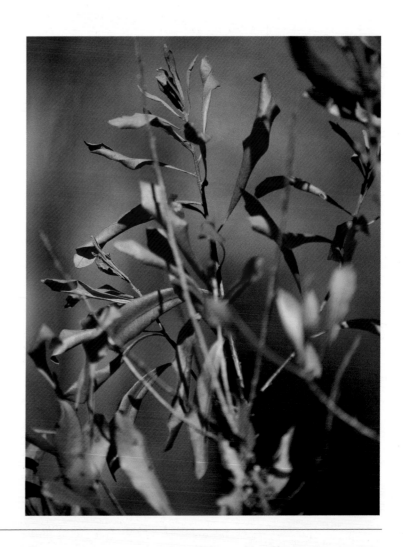

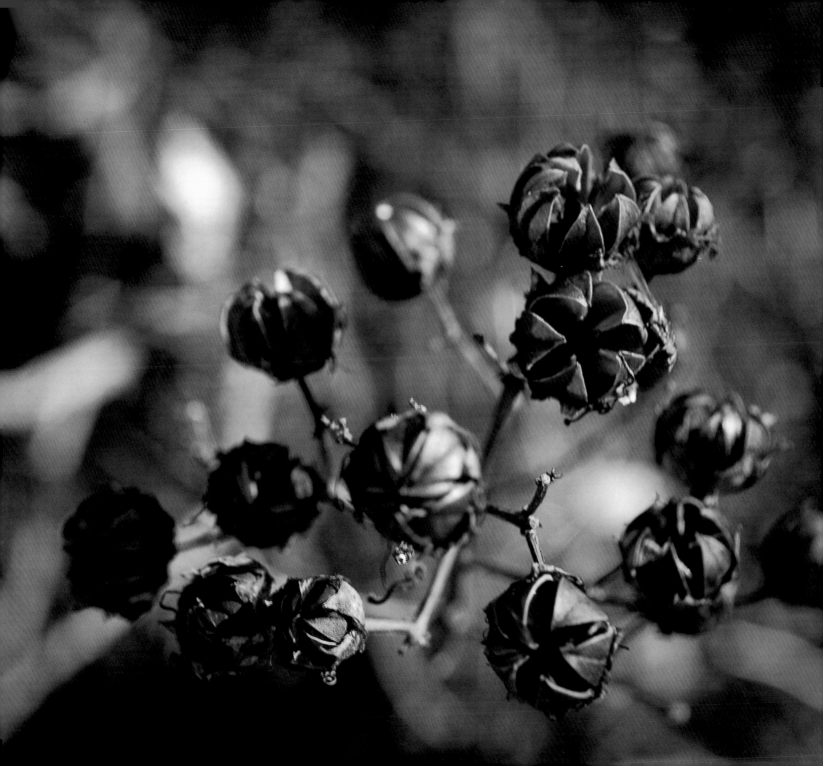

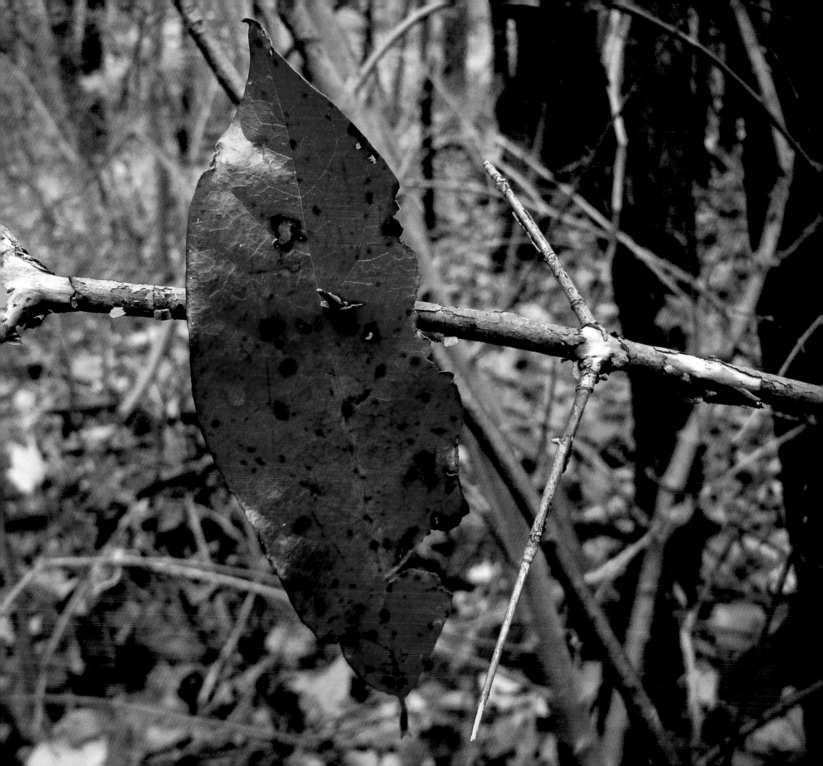

Lunch Reception Following John's Funeral

I sink deeper behind a dark cloud.
A woman has been chatting
at me for fifteen minutes—
telling me all the good things
God taught her through suffering.

She tells me the first thing to go through her mind
when she heard of John's death was the verse,
"Unless a grain of wheat falls to the ground
and dies, it bears no fruit."
"God will use this death for good," she adds.

My mind explodes, "Can I punch her?"
But the lip-service smile reaches
my mouth as I say,
"Yes, others have said the same thing."

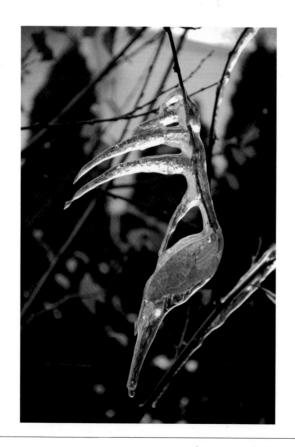

Her own loss has been
tremendous, and yet I have
space for no more grief.
I am a bucket overflowing
and she dumps in more.
Dumping and dumping.

She leaves for a few minutes
of blessed relief, but now
she is back again to present me,
like a celebrity, to her friend.

My body feels like a time bomb;
at any moment pieces could
fly off in every direction.
Screaming obscenities
would be a release.
I can't;
I'm not the type.
I sink deeper
into the blackness,
bottling it all.

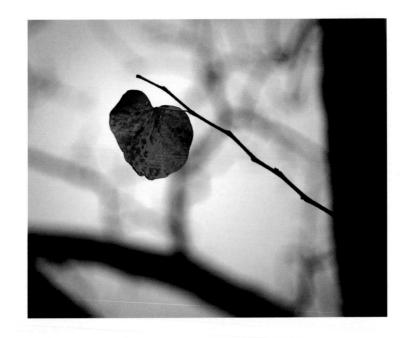

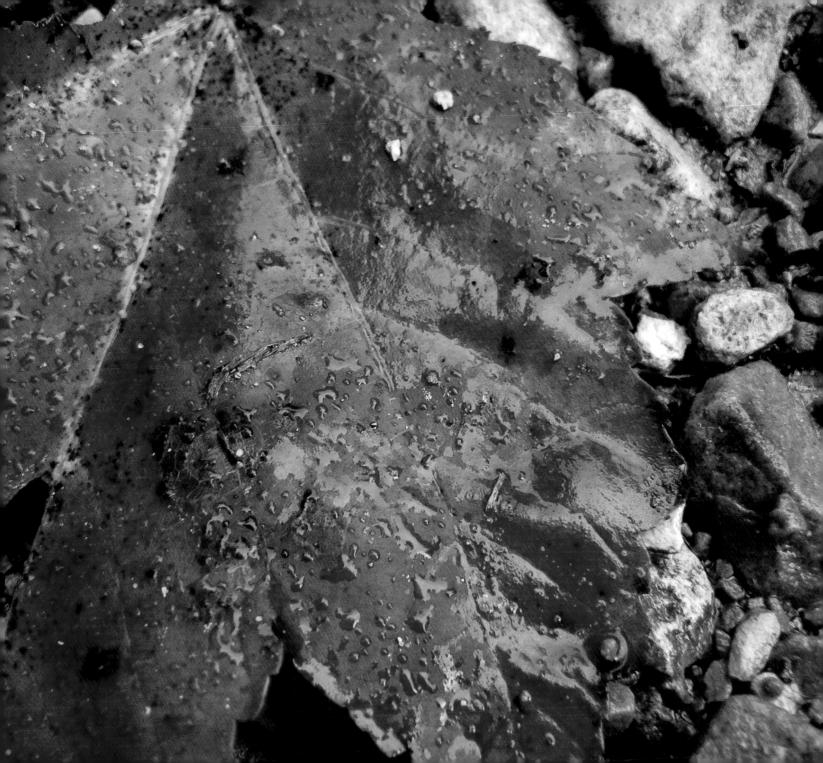

Let Me Wrestle

"God will get you through."
There are tears in his eyes;
I want to kick him.

A mental answer for the brain,
yet my heart is raging.

Can't you let my world be out of control?
Do you need to fix everything?
Can't you let the rage be what it is?

Let me wrestle with God
through this night
and trust one morning
it will turn into a dance.

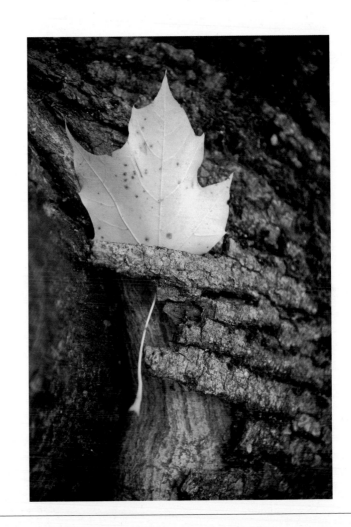

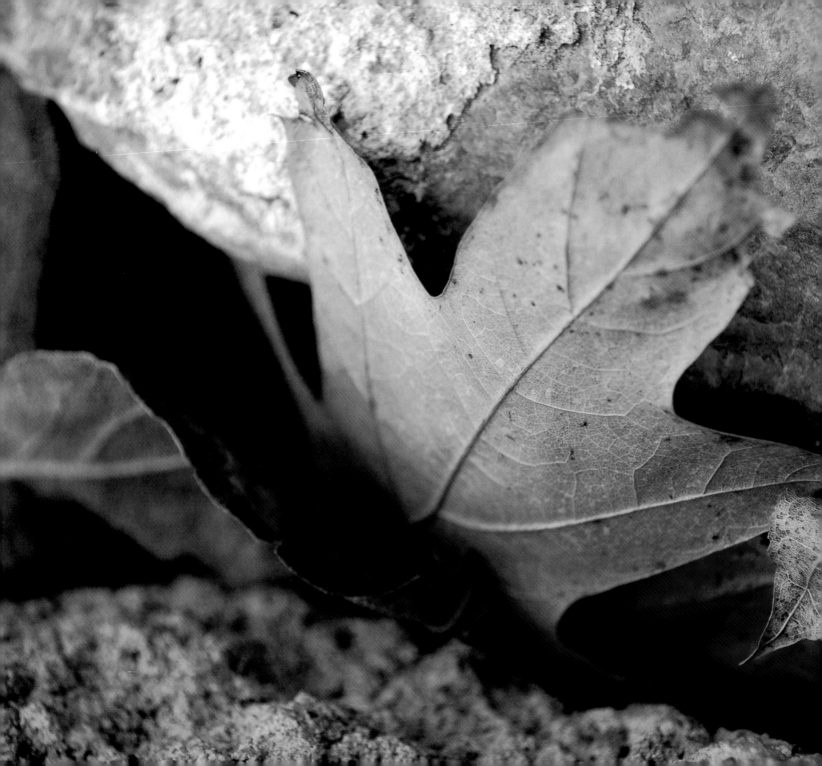

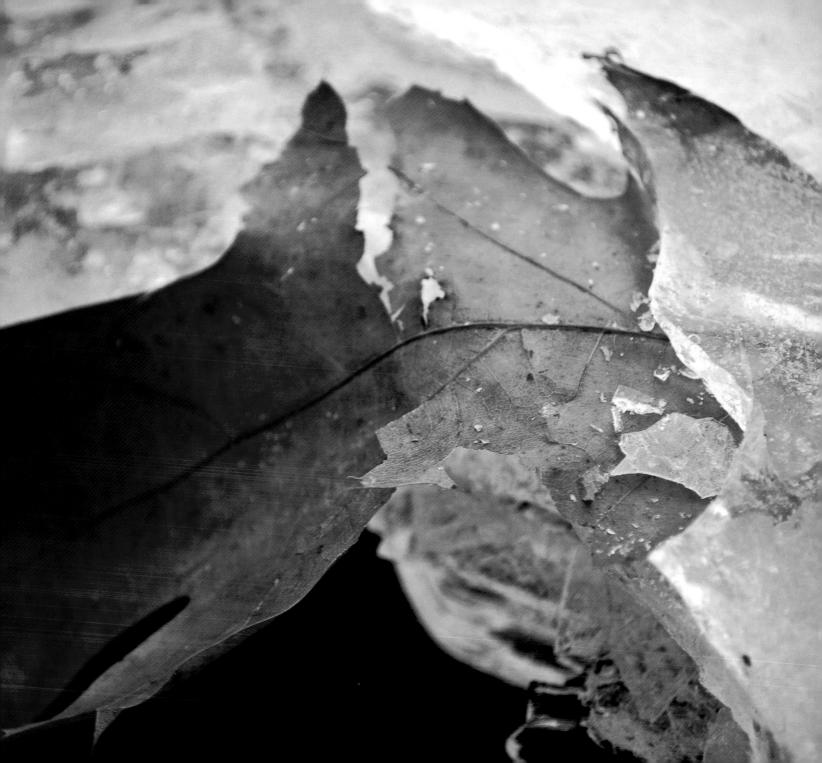

Swearing at God

Last night
I swore
at God.

I don't swear much,
never at God;
I waited for the proverbial
lightening bolt.

But I heard,
"I've been waiting for you to be real.
Now we can move forward together."

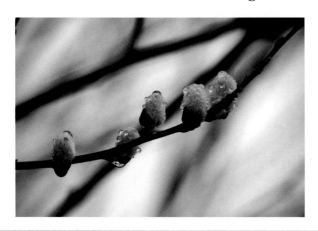

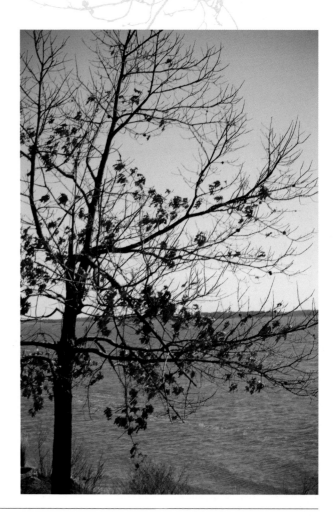

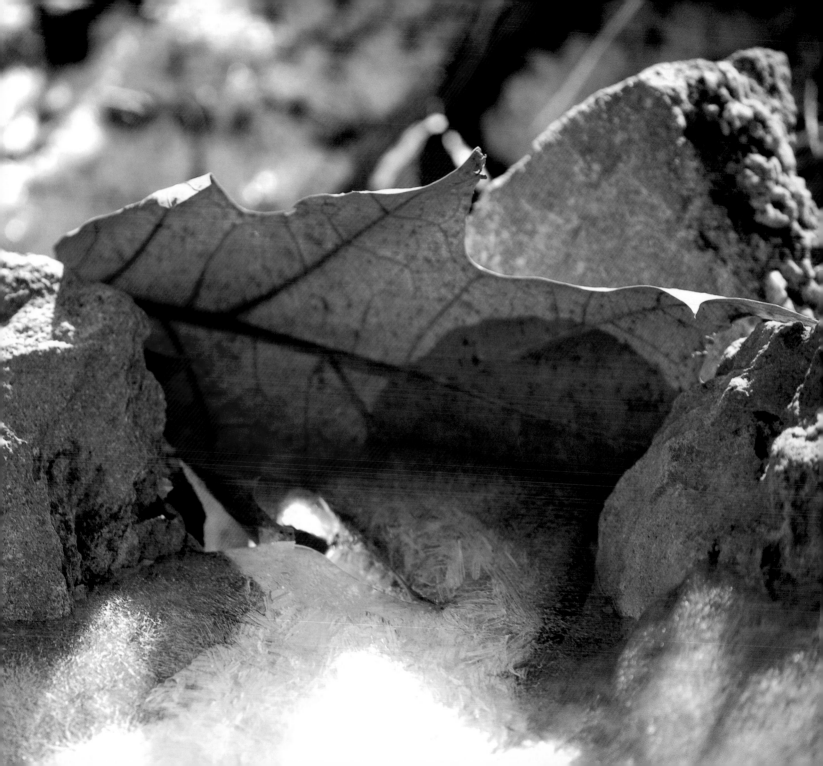

God, Life, and Love

I thought I knew you, God.
My life was planned—John, children, Thailand.
We were following a call—serving those in need.
We had vision, purpose, dreams.

One sunny Sunday morning
and one drunk driver collided in time.
John and Thailand exist in another world.
I search for the meaning of life and pain;
I long to know God in this.

Is it true what the artists tell us,
that shadows are as important as light?

Can I befriend my own shadows,
acknowledge their place in reality?
Hiding them has kept me locked up.

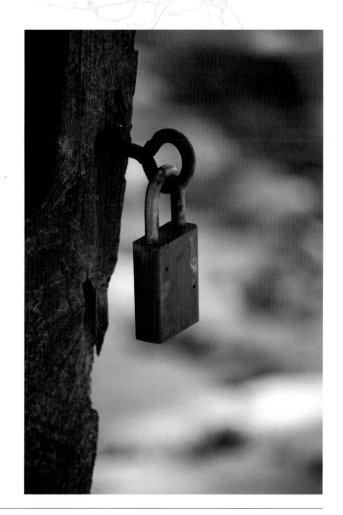

Where is the place to be free,
to be at liberty to live in wholeness?
Is it not to live the truth of the shadows,
and thus receive and see greater light?

I struggle to let the contradictions
be what they are;
no need to explain.
I try to remember each day is a gift
and to live the right now, today, every day,
fully present to God, to life, and to love.

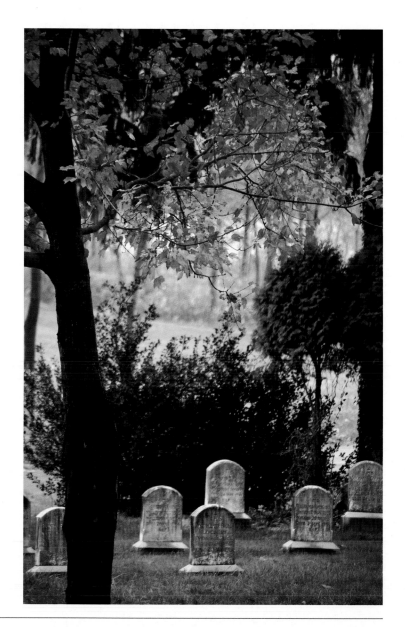

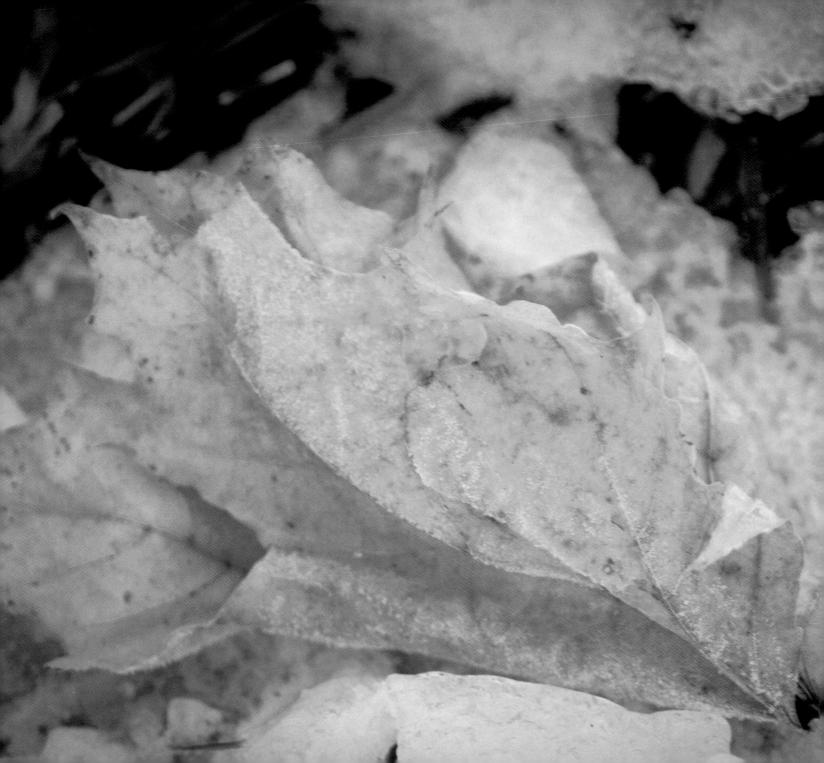

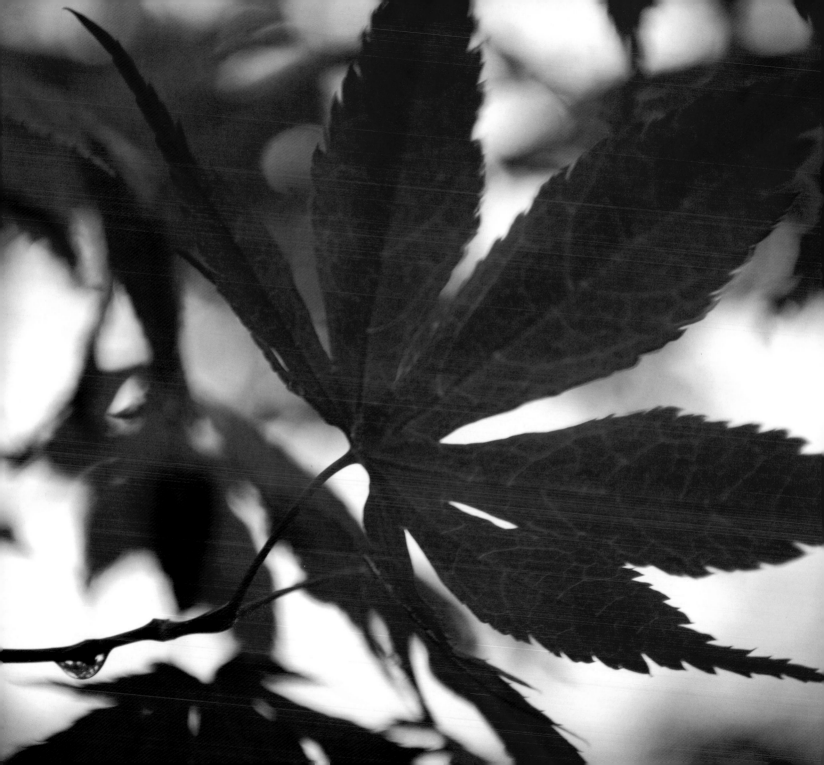

Your Stories

So many stories have gone
that only you knew.

What were you reading, as a boy, when you hid in the tree,
hoping work would get done without you?
What were you dreaming of
when you stared absently out the classroom window?

What was it about Hawking's *A Brief History of Time*
that caused you to carry it around the world with you?
What did you do for me
that you secretly disliked doing?

What were you thinking about
as you drove down the road that day?
Did you know I stopped at a market
and bought *lamyai* just for you?

You are so much more
than the sum of your stories.
Yet that is all we have left,
so we will cherish them.

Returned to Thailand to Pack

I am back
in town two hours
when Nee's son drowns.

We sit for hours on her cold
cement floor. Long silences.
She prepares food for guests.
Chopping knife to board.
Pounding pestle to mortar.
Voices of muted wails.

We take our place in a long line
following a small box to the temple.
We place our little sticks on the box.
The monk lights the match.

Flames lapping up the beloved boy
to the heavens
sear through the heart of his mother.

Does God hold
all the pain of the world?
Today I wonder if God
cares at all.

Yet, Nee says God brought me to
be with her now.

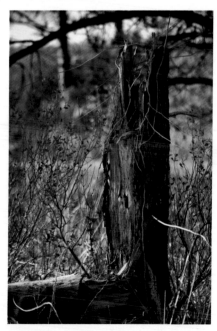

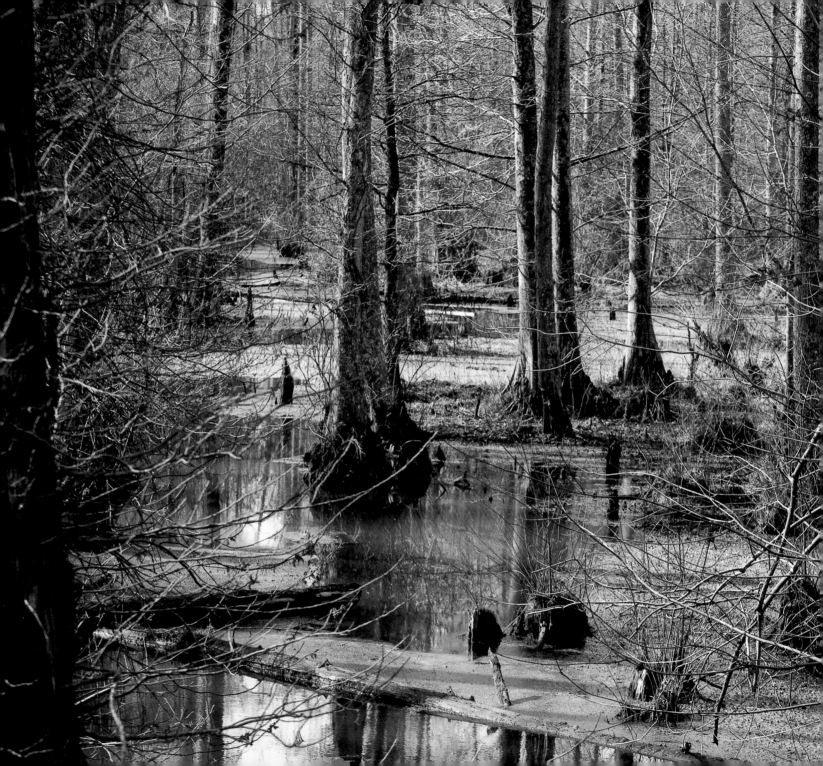

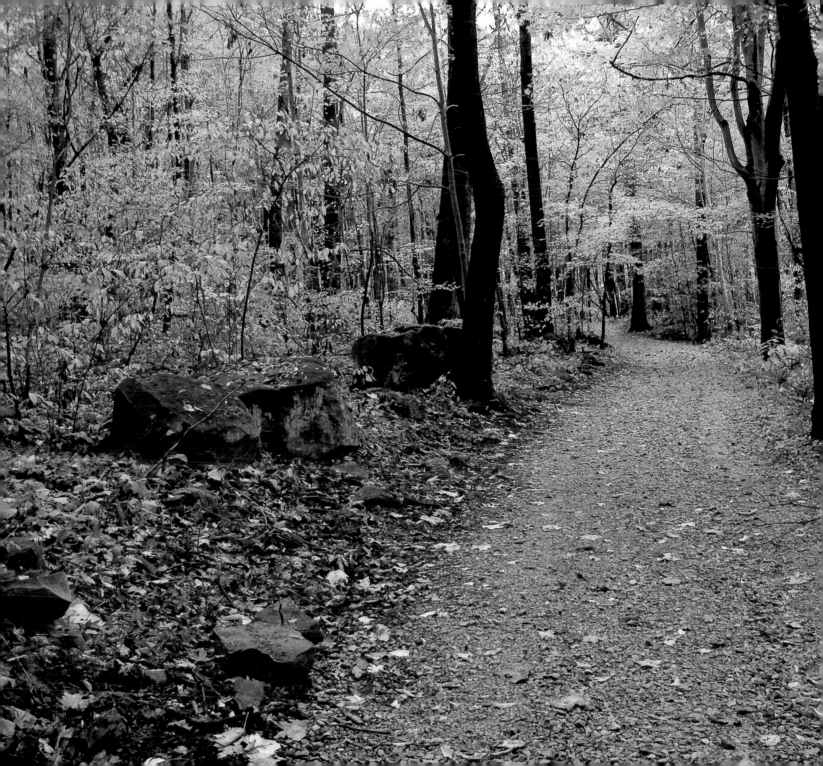

Finding God

I used to think that
the journey to God was about security.
Now I suspect it is more about being willing
to enter the risky territory of the soul's wilderness.

The wilderness is a place where you
must find God or die.
A place where you
experience life, real and raw.
Nowhere to hide. No pretense.

Sometimes I think I'll dare the entry,
but most often I get two feet in,
then turn and flee to the safety
of my climate-controlled comfort.

Months of a Life

January began with birth.
School days filled February.
March included high school and college,
and April a job and moving to Thailand.
In early May, I got married.

The last week of May my husband died—
I was catapulted to December.
People shouldn't become widows in May;
they become widows in December.

Time is short; the end is near.
Purpose seems fading.
Newness lost.

Then one day someone said,
"Janelle, it's only early June."
What wonder to realize
summer had only begun.

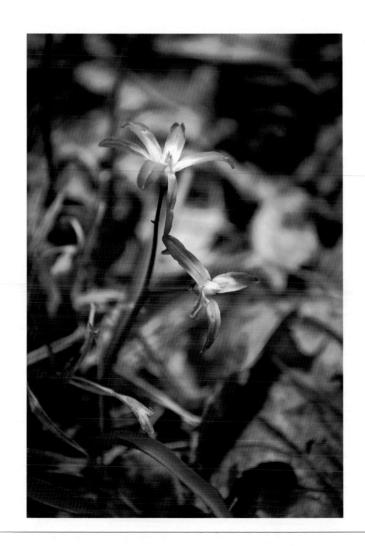

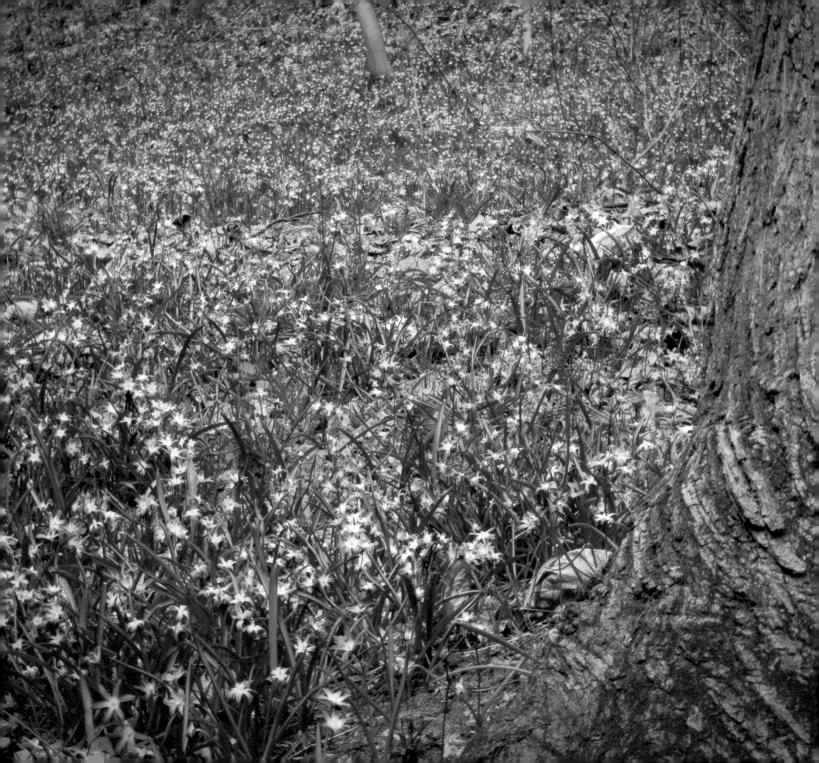

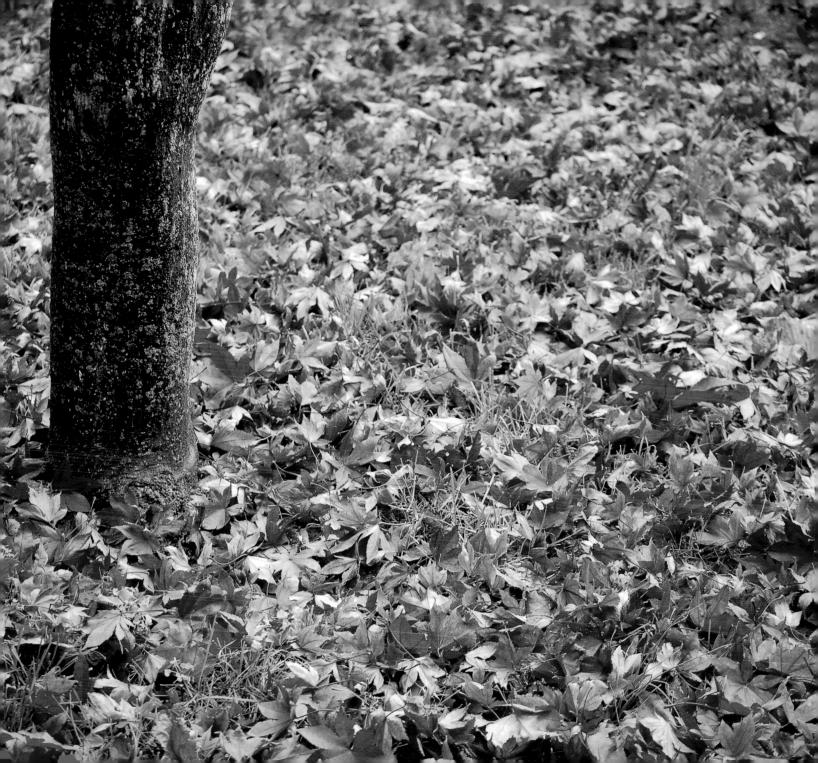

Air

Someone pointed out that today I could
breathe air particles that were once
breathed by either Jesus or Hitler,
or both.

I don't get to choose.
Air that Jesus breathed could
occasionally circulate through my lungs,
as could Hitler's.

Jesus also meets Hitler in
a rural church in Northeast Thailand.
Communion is served in old Nazi shot glasses,
red swastikas stamped on the bottom.

Glasses filled to serve Hitler's men,
to bring them laughter,
to help them forget.

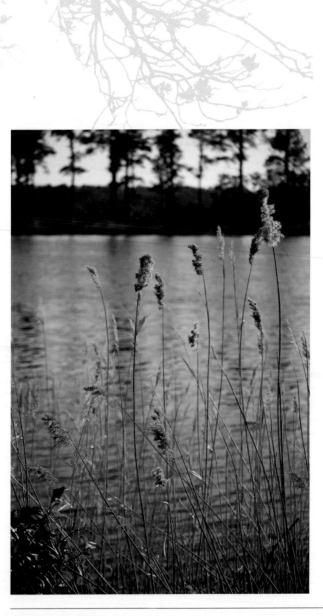

Glasses filled so that we remember
the blood of Christ,
poured out for the sins of many,
to remove our separateness.

Are we so separate?
Hitler and Jesus,
my enemy and me,
a drunk driver and John?

Everything in me wants to scream,
"Yes, damn it!"

And I breathe.

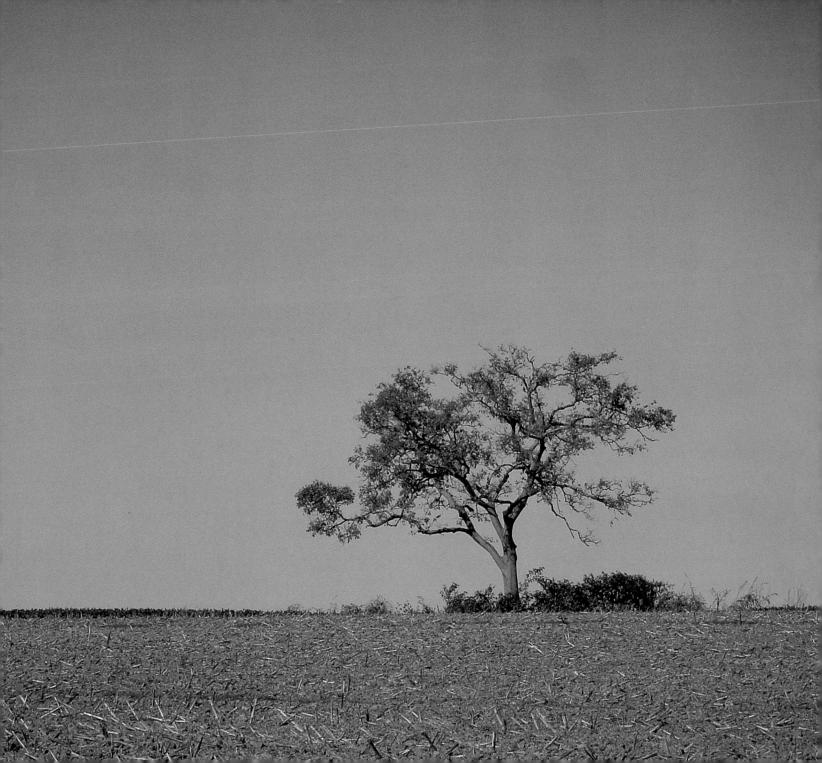

Questions

It is hard to live life's questions.
It's easier to live a defined life
with all the answers spoon-fed.

You don't have to think.
You just believe what you're told
and go on your merry way.

Questions cause revolutions,
and reformations.
They challenge us to go deeper
into the soil of our lives.

But questions feel threatening.
We may have to give up
the security of knowing the answers,
the security of life the way it always has been.

I'm growing to see that authenticity
is worth the risk of inquiry.

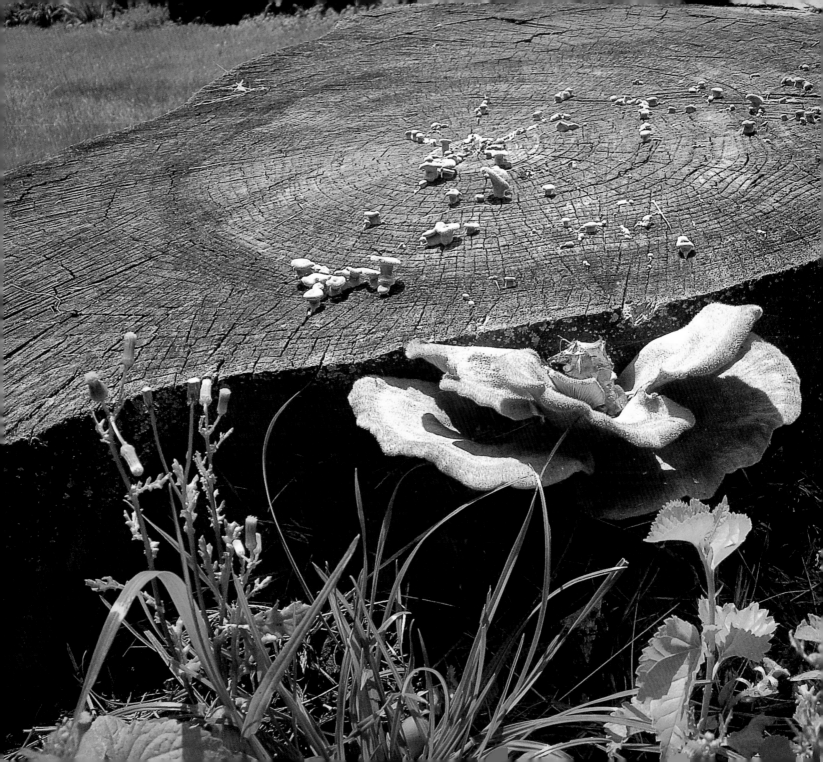

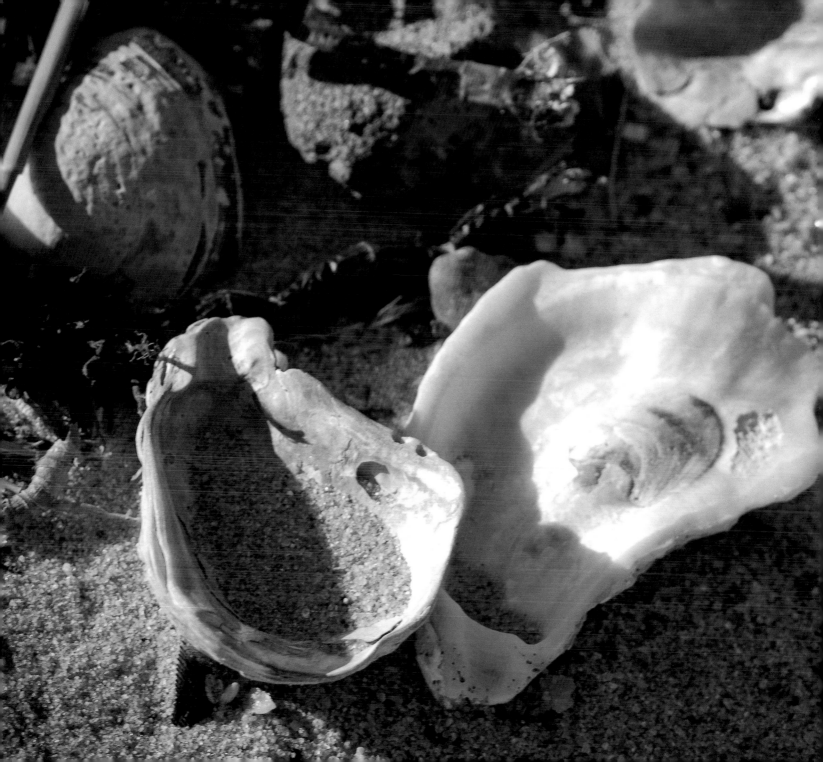

Pearl Earrings

My last gift from John—
worn every day since he died.
Twenty-two months of hopes to find
treasures in the midst of pain.

Dead inside,
I resolve to join the living.
Playing with children,
one earring disappears,
impossible to find.

Choosing to love and live
is no guarantee there
won't be more loss and death.

But remaining buried in death
eliminates the possibility of life and love.

Sometimes even old treasures must die
to make room for the new.

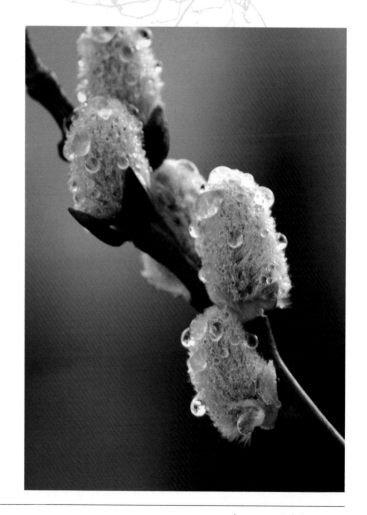

Journey through Worlds

Explorer by nature,
I traveled and lived in foreign lands.
For the journey, I took a passport,
plane tickets, and luggage,
learning new languages, ways, and attitudes.
Filled with excitement, adventure,
challenge, and wonder.

But life's circumstances brought me back—
grieving the loss of a husband and a life.
A passport buried in a drawer while
luggage collects dust.

Slowly, a new exploration dawns
within the territory of my soul.
For this journey I need stillness,
trees and rivers, poetry and journals.
Again learning new languages, ways, and attitudes.
Filled with anger, despair,
flickering hope, and waiting.

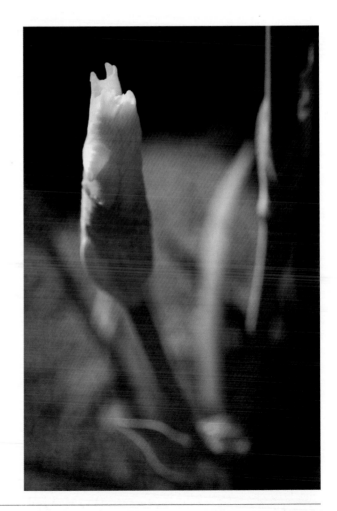

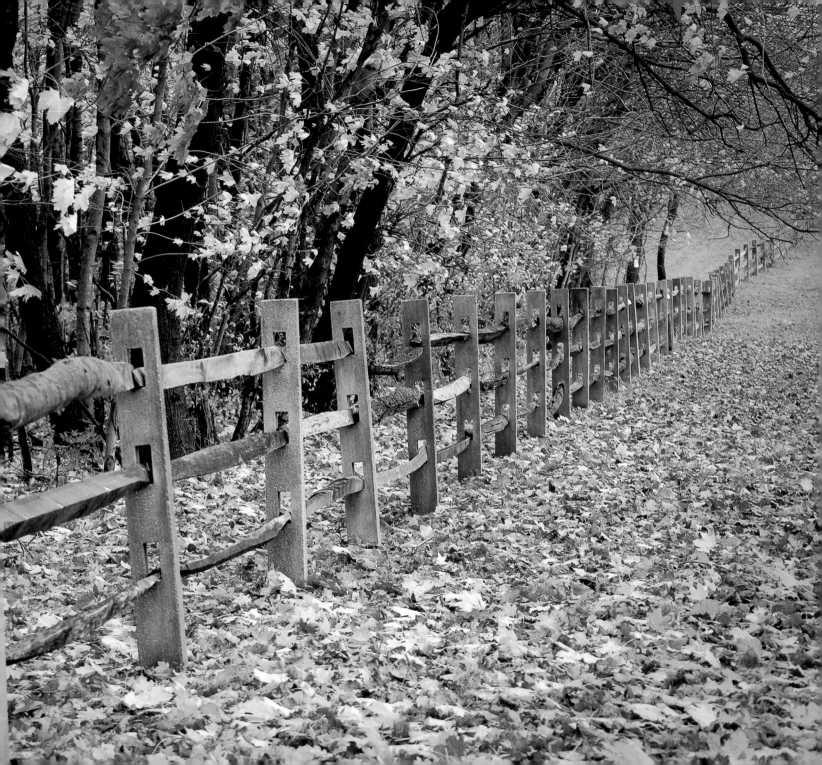

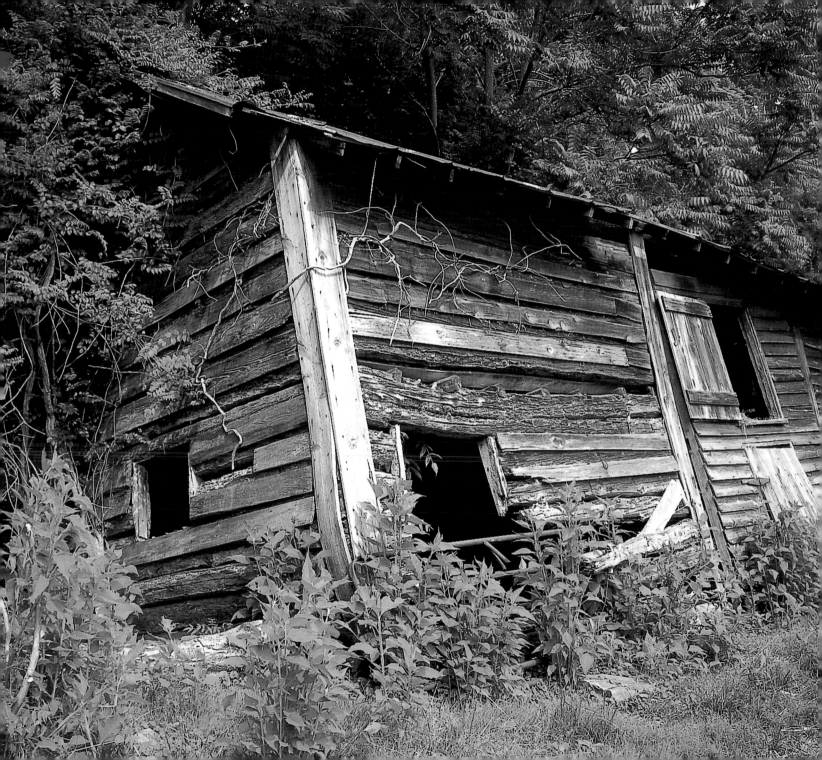

At the Tomb

My feet drag my heavy heart
to the tomb of my sorrows.
I carry perfume to anoint
the death of my dreams.

I go, knowing a boulder
bars my way.
Who will roll the stone away?
I have no idea. Yet, I go.

Compelled to keep honoring the loss,
to go back to lost desires.
Pulled by strange hope
that this death
will yet lead to life.

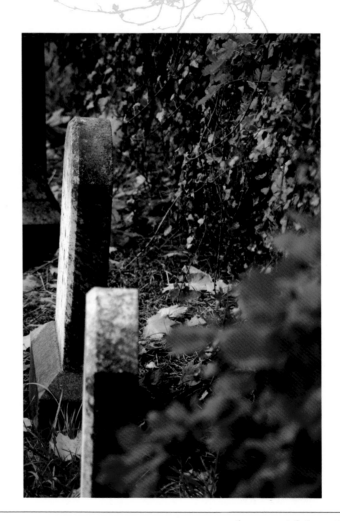

Mary Magdalene

I still sit here by this tomb.
The others heard the angel's words;
it was enough for them, and they left.
Why couldn't it be enough for me?

My heart longs for more than words.
I wander in the garden
distressed in my tears.
I frantically search for answers
from anyone I meet.

Then I hear love speak my name.
I turn, I cry, I reach out.
What I've lost has returned.
It is mine.

But love gently invites me
not to cling to what I've lost,
to love with hands held open,
to receive and to loose.

Now I begin to see anew the love
in the voice calling my name.
Now I've experienced love that is enough
for me to risk letting go of the loss
and moving into new life.

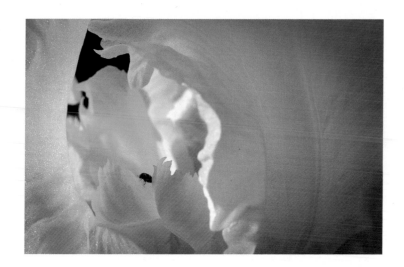

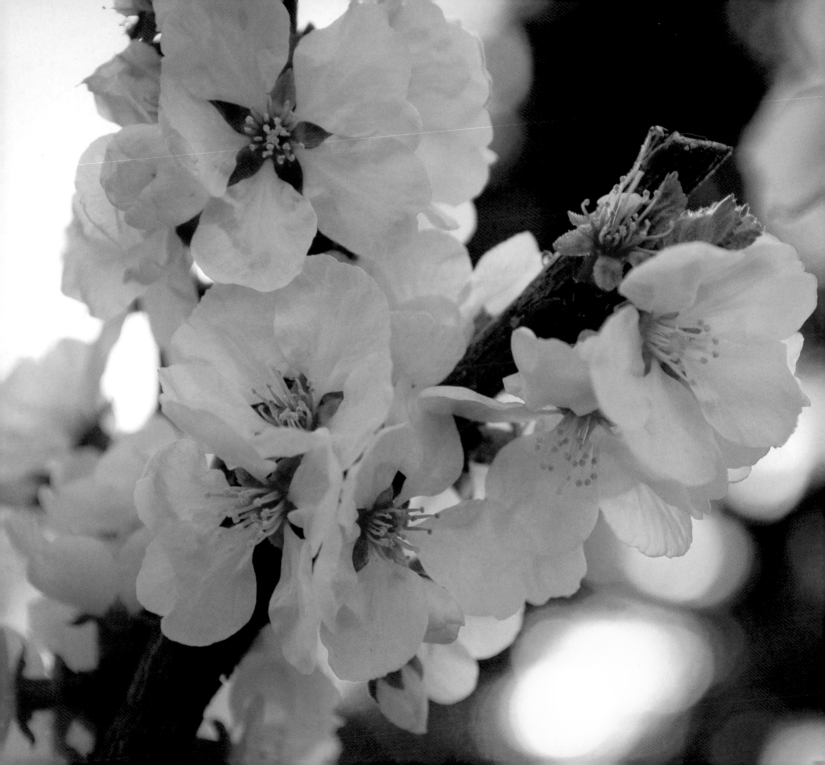

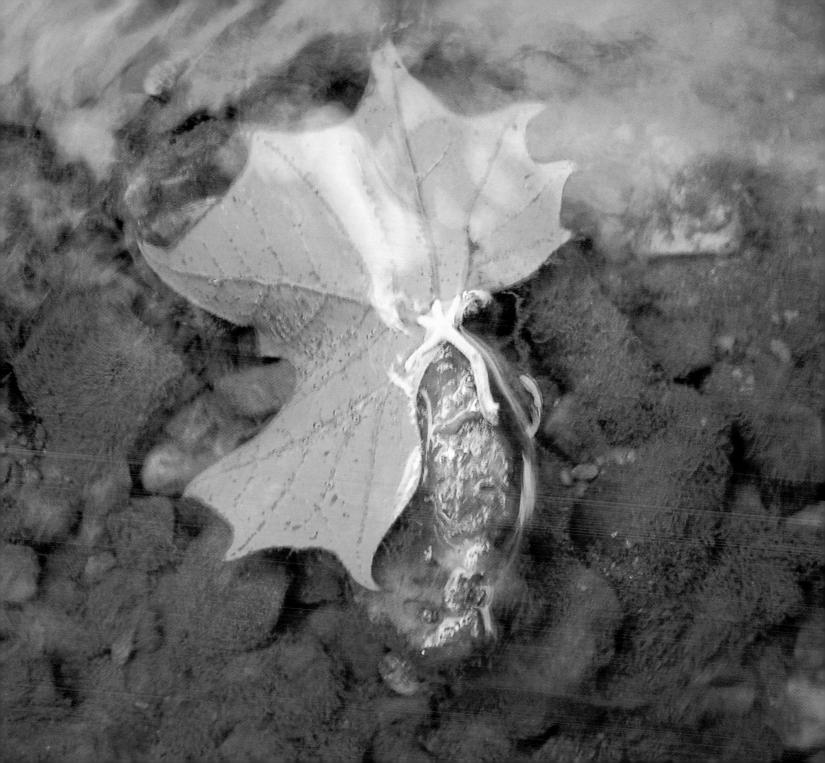

River Ride

I'm bobbing on a river,
going where it takes me.
Oars and sails long lost.
But would I know where to steer
if I still had them?

Often the current is fierce,
and I feel ready to go down.
Bashing up against the rocks,
I fight and thrash for survival.

Just in time, a calm,
and I float like hollow driftwood,
exhausted.

Occasionally wild and exciting,
a hopeful future seems sure,
adventure in sight.

Sometimes pleasant and still,
I rest in the peace of the now.

Should I let go and ride the current?
I don't know where it is going.

I hear the gentle voice say,
"Trust the river.
It knows where it is going."

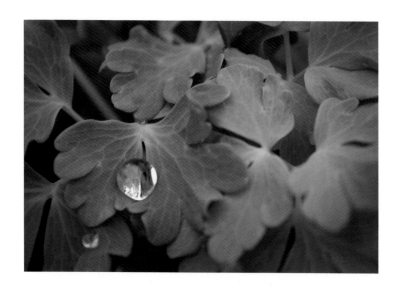

True Me

I know well the me I'm told to be,
but I don't know the me
that was given me to be.
The true me, the inner me,
the deepest me remains unknown.

When I live the me I'm told to be,
I fail, I disappoint, I hurt.

When I show only the me I'm told to be,
I feel shallow and deceptive.
I make promises I cannot keep.

Will I choose the risk
of turning inside out?
What will I find as I get to know the me
I am made to be?

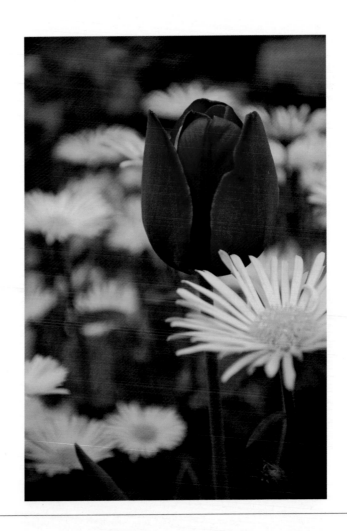

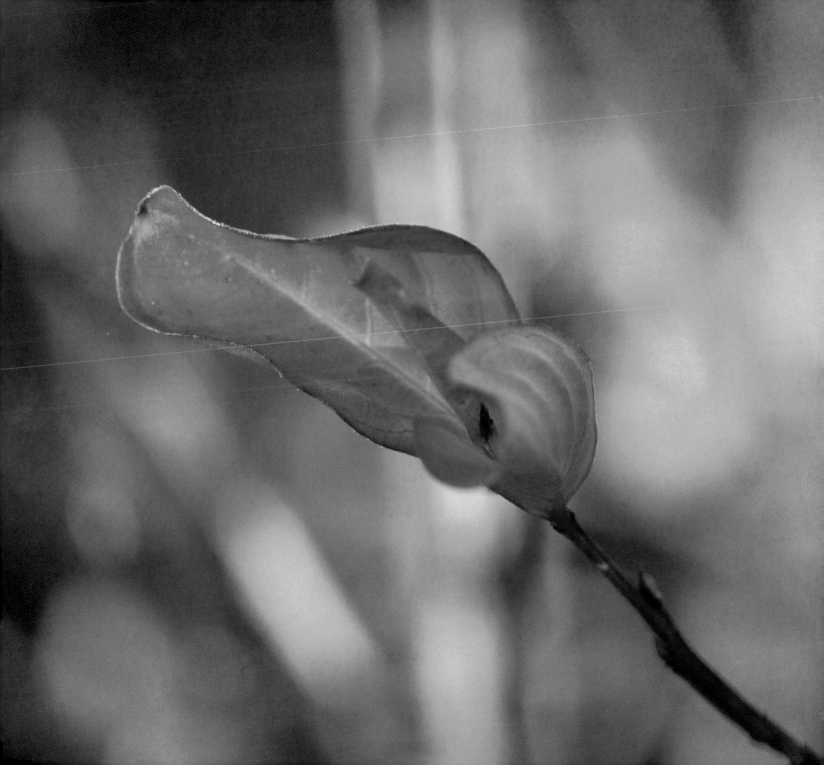

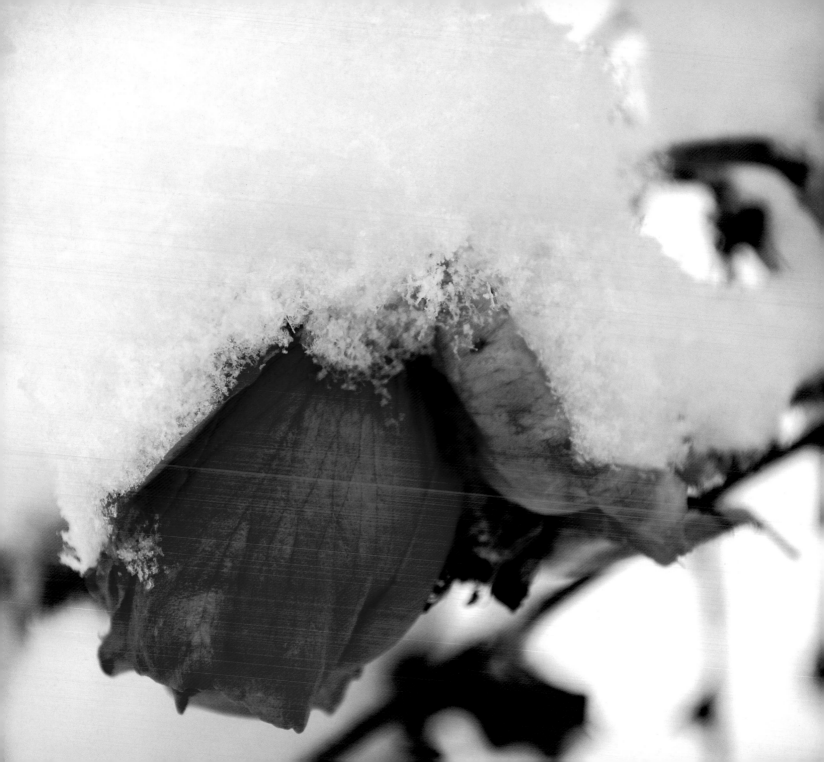

Who Interprets?

I always prayed
for safety and joy
and success in my
God-led endeavors.

I used to think God's children
could expect these things.
Isn't that what "abundant life" means?

Then I went to Haiti and Honduras.
Then I read about Christians in China.
Then I lived in Asia.
Then John died.

Then I read the Gospels again.

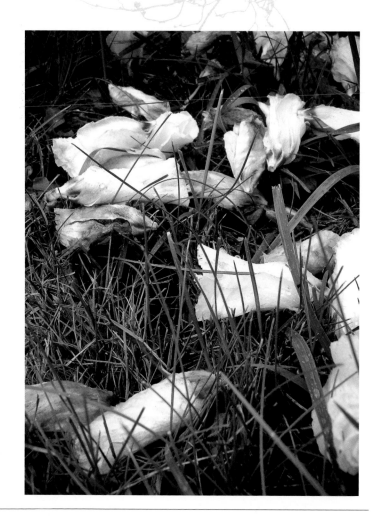

Which Woman's Jesus?

One preached, "Pray in the name of Jesus."
There is power in that mighty name.
Your life will demonstrate victory;
you will experience healing and wholeness.

The second told of Jesus walking into the wilderness.
No food, no nourishment, just rocks and dirt.
Emptiness, no sign of the three-day resurrection.
Forty days of destitution.

The first gave easy answers found to solve life's problems,
just pray with faith to move the mountains.
After all, God is a God of miracles.
Jesus will turn your mourning into dancing—just believe.

The second admitted she didn't have the answers.
Why are there wildernesses in our lives?
Why do we suffer through pain and loss?
All we know is that Jesus walked there too.

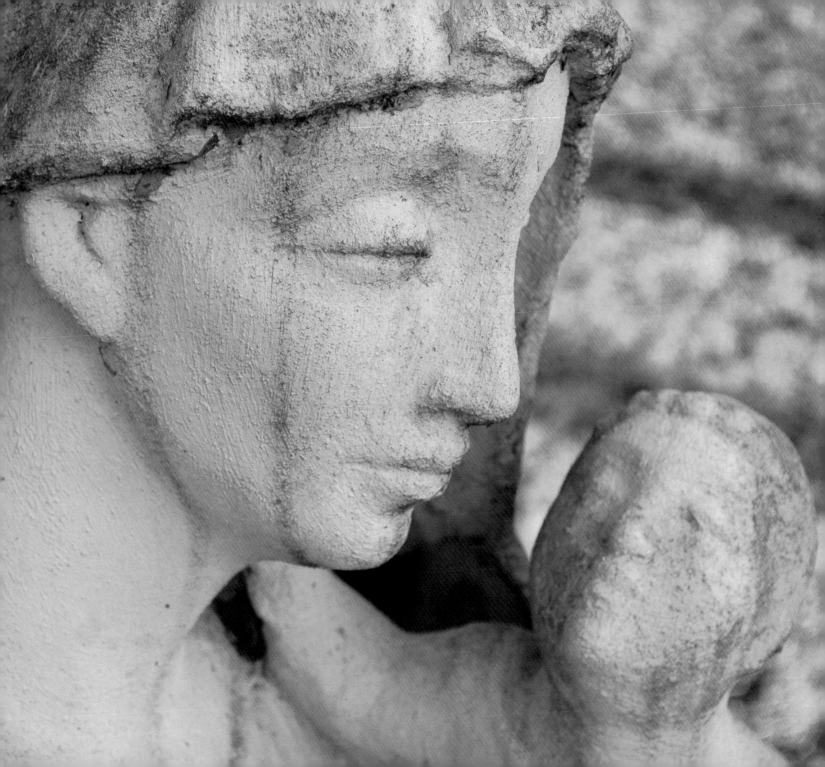

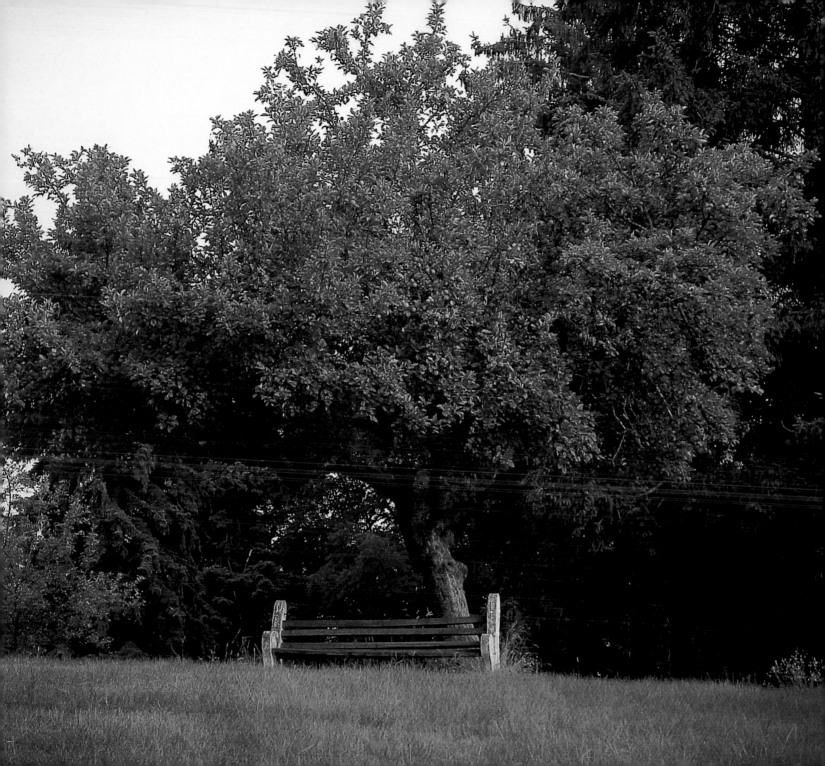

I Miss

Drinking coconut water by the dam,
ignoring the mosquitoes biting our ankles.

Reading together,
my falling asleep to your books;
you falling asleep to mine.

Browsing in 7-Eleven,
just to enjoy the air conditioning.

Walking the streets of Det Udom.

Motorcycle rides on the country roads,
feeling the wind and exploring new places.

Listening to you sing
Micah to sleep at night.

Dreaming of the future together,
our next place to live.

You.

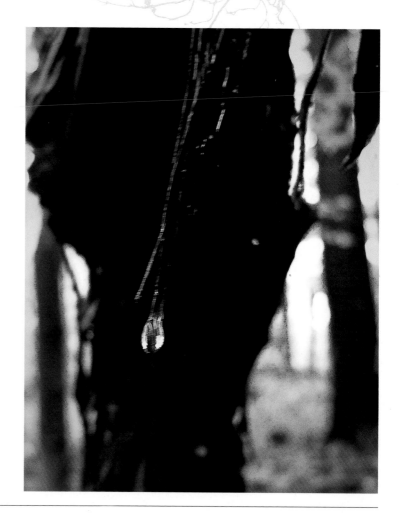

Resurrection

I'd rather just skip to a resurrection.
I don't want to feel the death.
But then it wouldn't actually be a resurrection,
it would just be plain old unappreciated good luck.

What is a resurrection if it is not first
enduring the depths of suffering?
If I do not live through the depths of loss,
how can I experience the riches of the resurrection?

So perhaps today, I'll muster the courage
to carry my cross for a little while more.

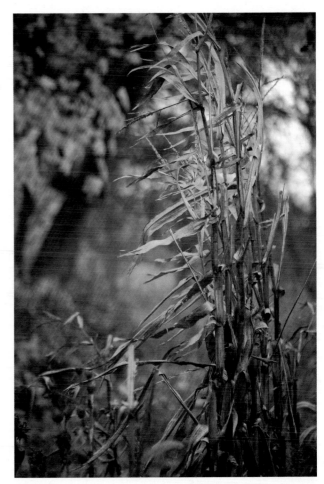

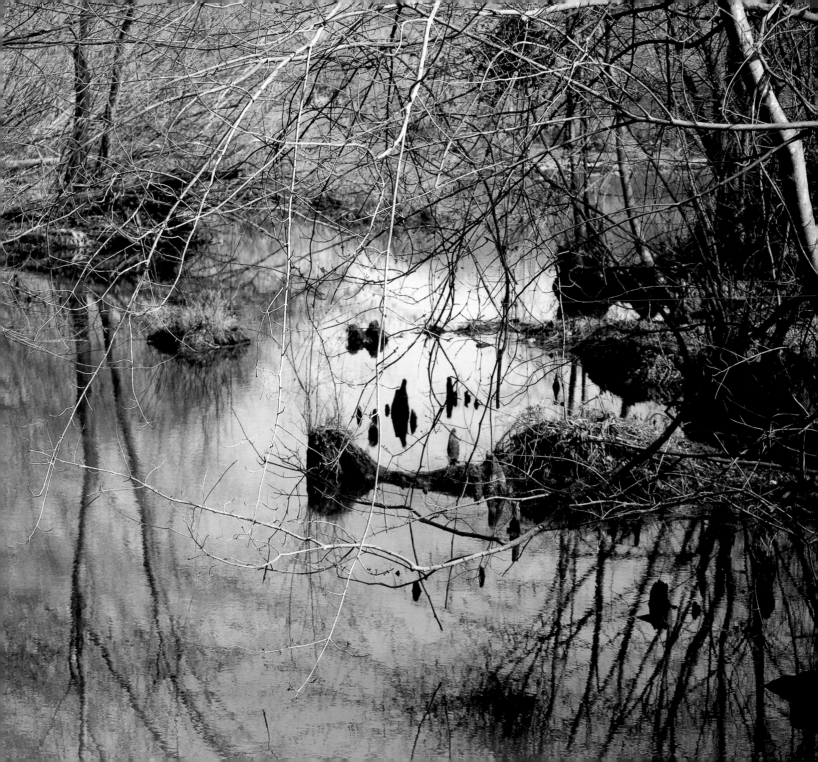

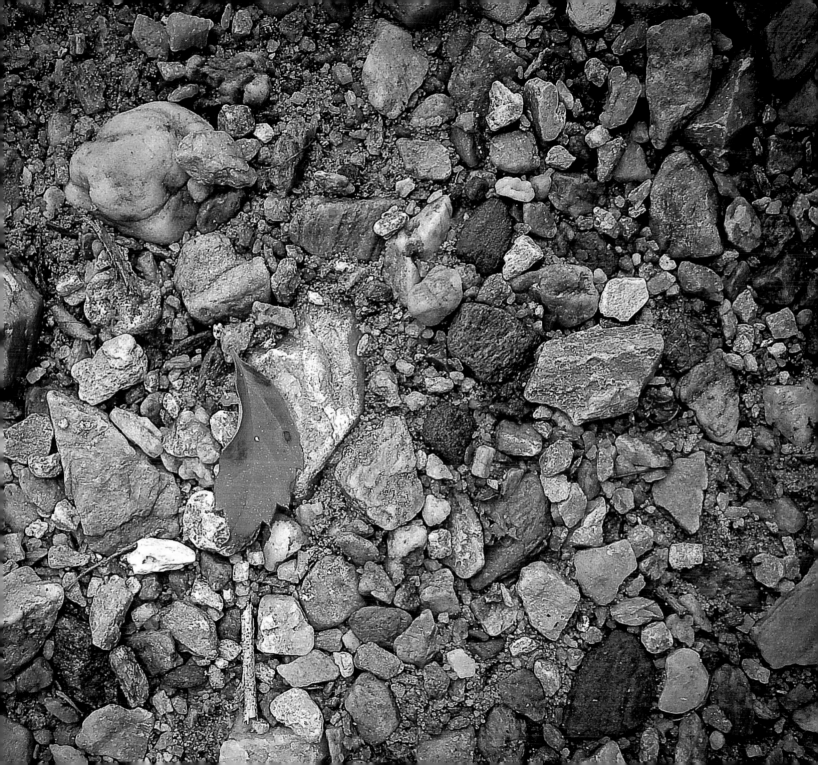

Splinters of Pain

I hear the shatters of breaking glass as
people remember the pains of their past.
Splintering chunks,
razor-sharp edges,
unhealed wounds cut deep,
trauma passed on.

Would we risk the edges?
Can we pick up the pieces
and hold them until they're smooth?

Carefully rub.
Meticulously polish.
Lovingly embrace.

Can we see them as deposits,
embedded in the mosaic of our souls?

A bright red here.
An oblong shape there.
Just so.

Is beauty formed from broken bits?
Artfully arranged?

Celebrating the union.
Toasting the uniqueness.
Marveling the design.

Healing our corner of the universe,
wholeness and life passed on.

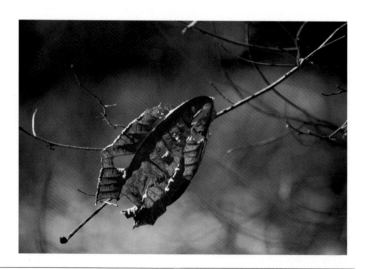

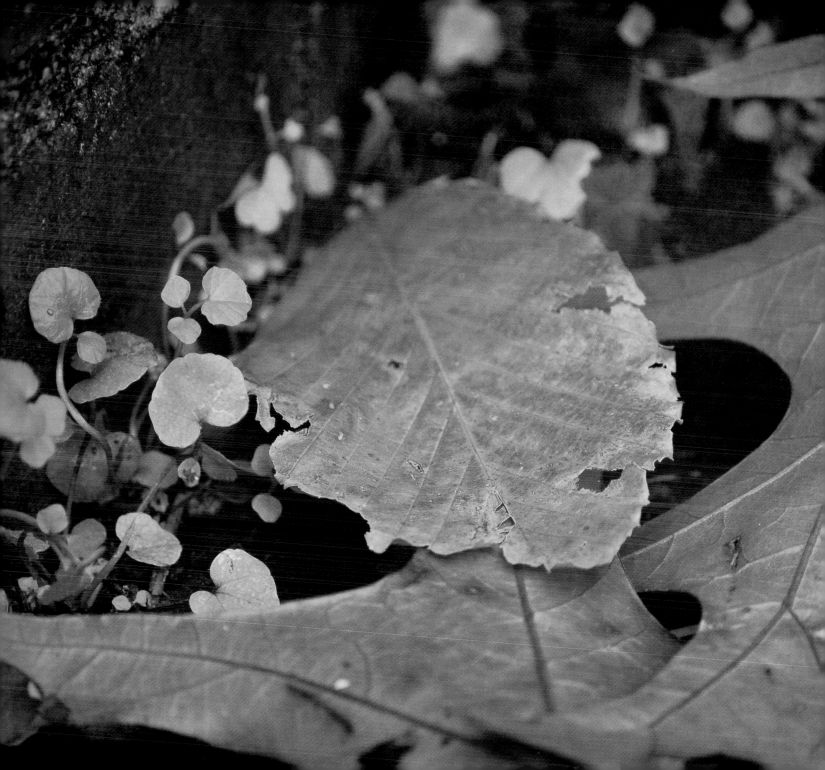

November 4th

Shock remained,
the first birthday after his death.
His second birthday, denial dominated.
His third, anger.

I kick brown, fallen leaves.
Green life below insists its presence
remains known.
Life and death in a slow dance.
Nuzzled close, whispering amiable
words in each other's ears.

My anger feels like betrayal.
I am angry at John.
I hate myself for it.
It wasn't his fault.

I sit by a statue of Jesus.
"God, life sucks," I mumble.
Jesus replies, "I know."

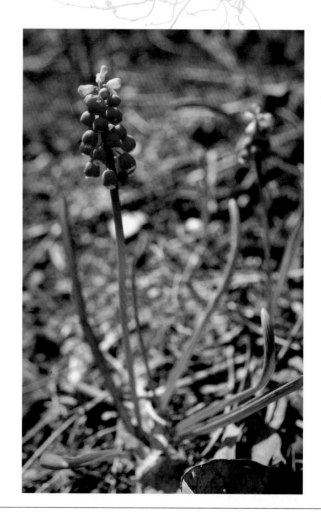

I want to forget.
Bury the past and move on.
Shake my fist in the air,
and say good riddance.

A shift of vision,
eyes to see beyond
my present perception.

John comes, arms open wide,
with an invitation
to dance.
Dance free,
dance life.

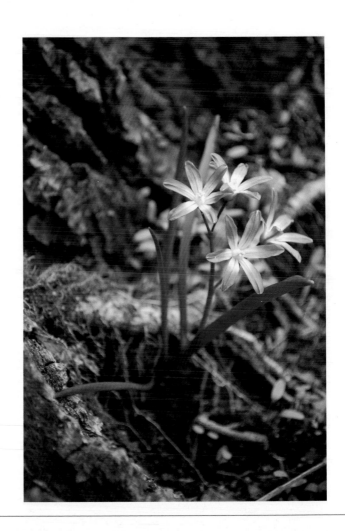

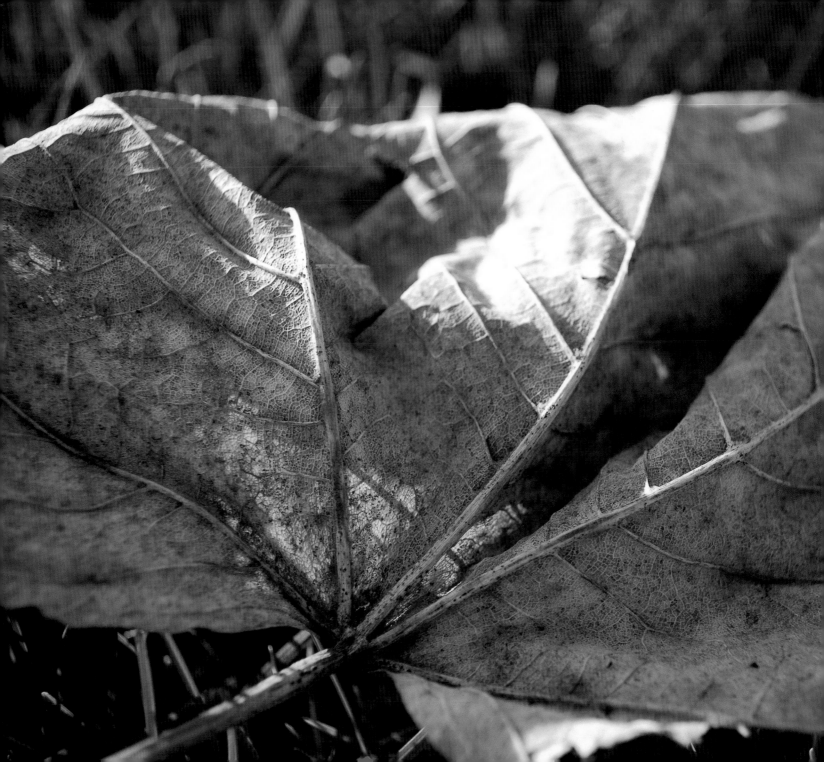

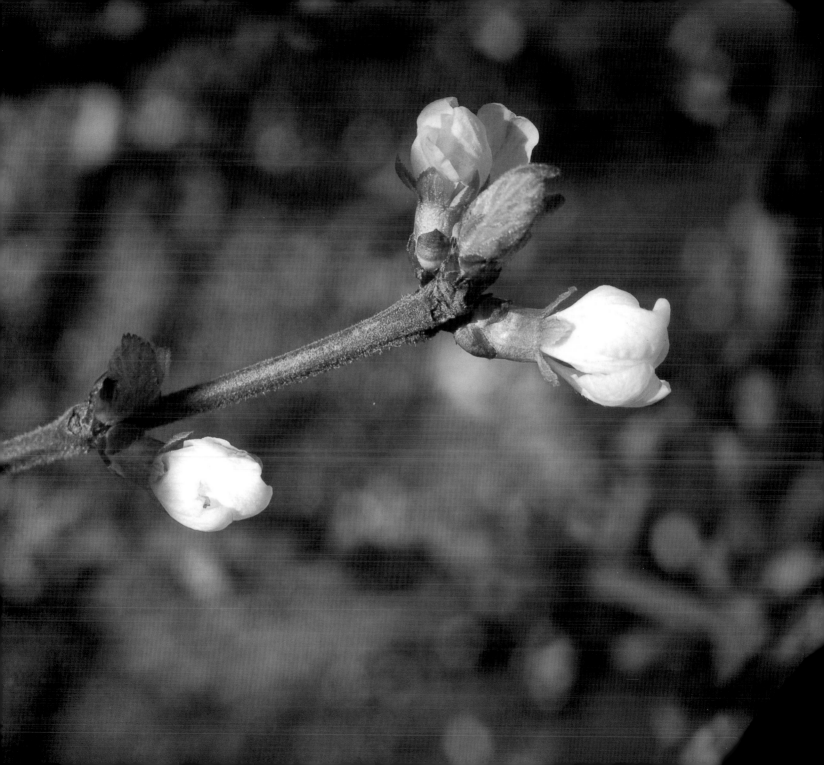

The Message of the Flower

Is there a silent message in this flower?
Will I take the time to sit and hear?
It has been calling me today.

I am tired to the core,
my forehead dented in a grimace.
There's an iron weight upon my shoulders,
a costly security blanket
I refuse to put down.

Yet there is this call, an invitation
to a homily without undertones of condemnation.

Will I take the time to sit and hear
and drink deeply of the message of the flower?
And find a way to bloom within the madness?

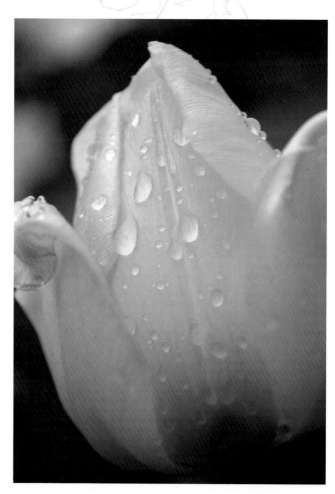

Preparing for Grief

Two content missionary men
who had never experienced grief
once asked me if there was any way
to prepare for this loss.

I don't think so.
But I have a suspicion
that if they looked deep
into the eyes of the street children
until they found God in those eyes,
and if they continued that search for God
in the eyes of the beggars and the dying—
never settling for the quick glance
and easy answer—
they may be better prepared than most.

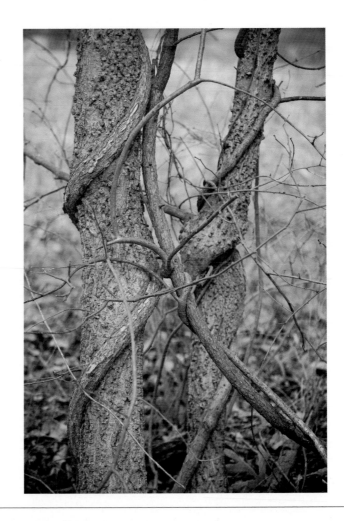

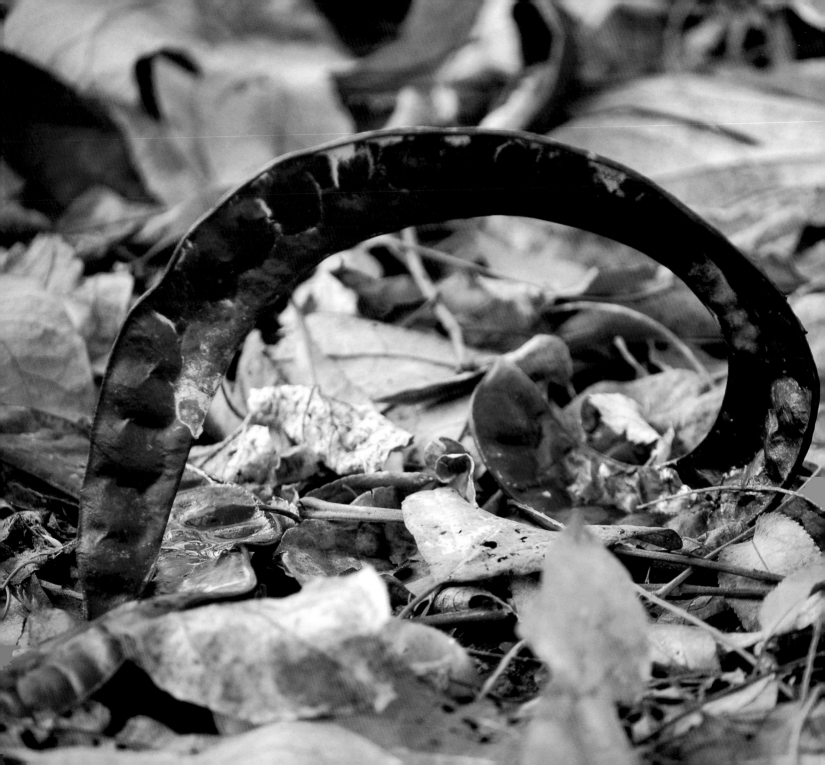

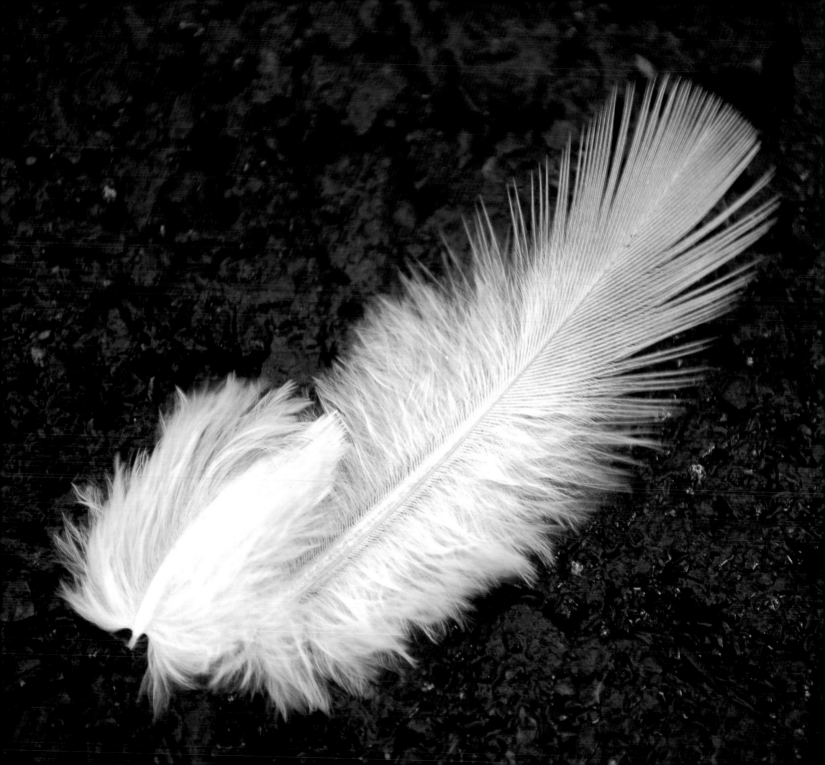

The Mundane and the Miracle

"Don't focus on the mundane.
Focus on the miracle," I heard.
It sparked a question,
What about the miracle in the mundane?

There is a holy seed in every stump.
Beauty is everywhere,
content, just waiting to be noticed,
waiting to be celebrated.

To live in the beauty of the ordinary,
to live in the holiness of simplicity,
that is the miracle,
the treasure to be found
within the mundane.

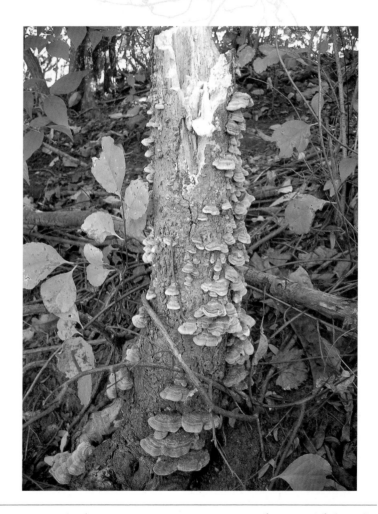

The Gift of Poetry

Until your death,
I hadn't written a poem
since high school English class.
It wasn't my thing.

Then came an invitation to write my story
in one hundred words or less.
I had to clear away the extras,
unearth the essentials.

Sifting through the rubble,
a ruby here, a diamond there.
Instead of a paragraph,
it came as a poem.

Just another stone to kick,
yet I notice, stoop, reach
examine, hold, caress,
and wait—
a pearl is there to see.

And so poetry has come,
a gift unforeseen,
to find my way,
to center
one line at a time.

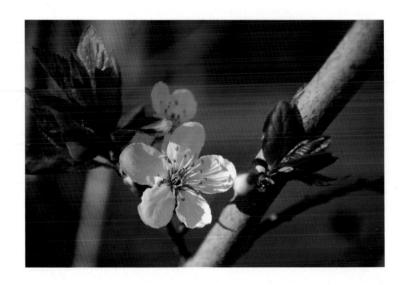

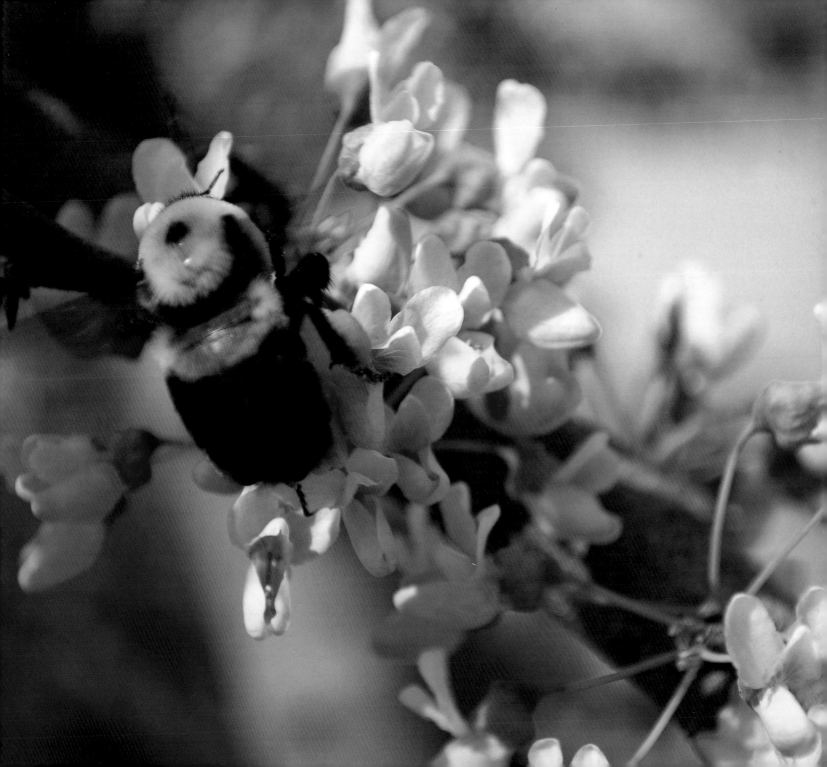

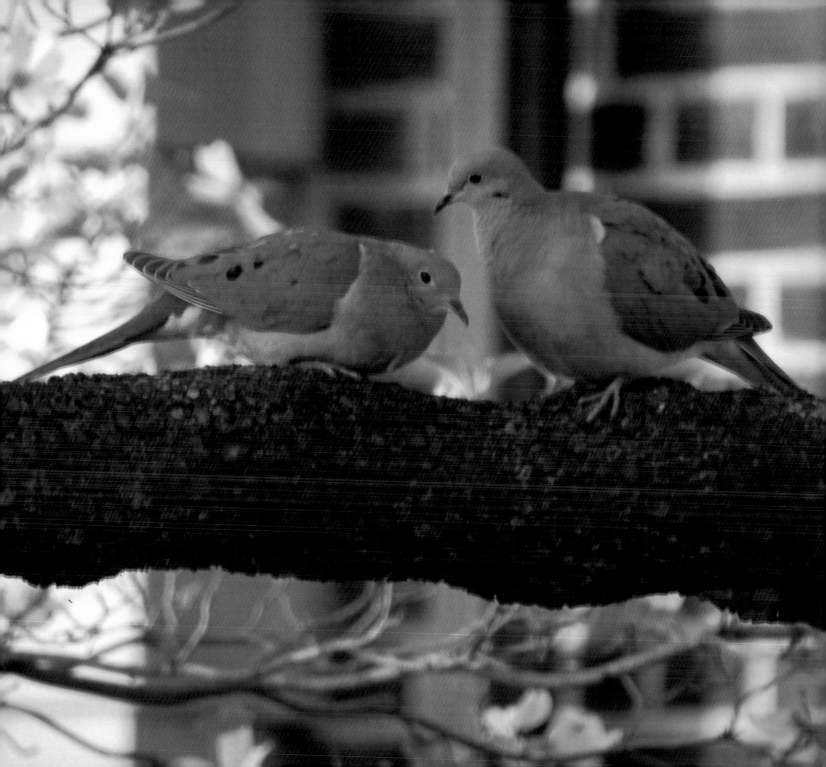

Tree in the Forest

Life from death—
falling leaves and branches
decompose.
Food sustaining life.

You are still here.
Sustaining.
Nourishing.
Changing me.

My view of life
fuller because of death.

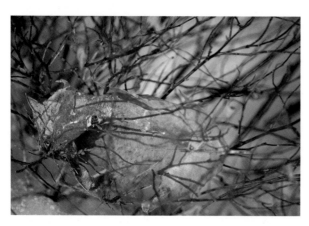

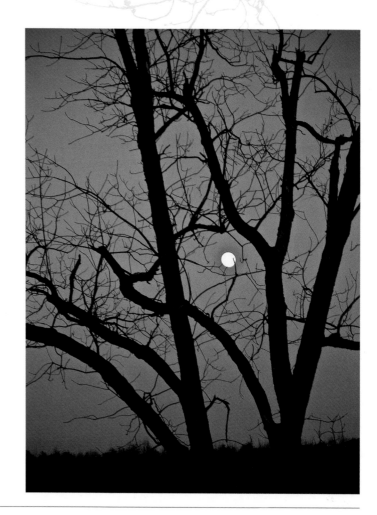

Recommended Reading

Descriptions and reviews for these books can be found on my web site at
www.journey-through-grief.com

Grief

A Grief Observed by C. S. Lewis
Grieving: Our Path Back to Peace by James R. White
How to Survive the Loss of a Love by Melba Colgrove, Harold H. Bloomfield, and
 Peter McWilliams
Life is Goodbye Life is Hello: Grieving Well Through All Kinds of Loss by Alla Renee Bozarth
On Grief and Grieving: Finding the Meaning of Grief Through the Five Stages of Loss by
 Elisabeth Kübler-Ross and David Kessler
On Life After Death by Elisabeth Kübler-Ross
When People Grieve: The Power of Love in the Midst of Pain by Paula D'Arcy

Reflecting on Loss

A Grace Disguised: How the Soul Grows Through Loss by Jerry Sittser
A Song for Sarah: A Mother's Journey Through Grief and Beyond by Paula D'Arcy
A Sacred Sorrow: Reaching Out to God in the Lost Language of Lament by Michael Card
Can You Drink the Cup? by Henri J. M. Nouwen
Everything Belongs: The Gift of Contemplative Prayer by Richard Rohr

Prayer, Stress and Our Inner Wounds by Flora Slosson Wuellner
Praying Our Goodbyes: A Spiritual Companion Through Life's Losses and Sorrows
 by Joyce Rupp
Transcending: Reflections of Crime Victims by Howard Zehr
When the Heart Waits: Spiritual Direction for Life's Sacred Questions by Sue Monk Kidd

Poetry/Writing for Healing

Poemcrazy: Freeing Your Life with Words by Susan G. Wooldridge
Poetic Medicine: The Healing Art of Poem-Making by John Fox
*Poetry as Spiritual Practice: Reading, Writing, and Using Poetry in Your Daily Rituals,
 Aspirations, and Intentions* by Robert McDowell
Thirst: Poems by Mary Oliver
Writing to Heal the Soul: Transforming Grief and Loss Through Writing by Susan Zimmermann

Photography for Healing

God Is at Eye Level: Photography as a Healing Art by Jan Phillips
PhotoTherapy Techniques: Exploring the Secrets of Personal Snapshots and Family Albums
 by Judy Weiser
The Little Book of Contemplative Photography by Howard Zehr